POSTCARD HISTORY SERIES

Bethlehem

D1595659

William G. Weiner Jr. and Karen M. Samuels

ARCADIA
PUBLISHING

Copyright © 2011 by William G. Weiner Jr. and Karen M. Samuels
ISBN 978-0-7385-7570-4

Published by Arcadia Publishing
Charleston, South Carolina

Printed in the United States of America

Library of Congress Control Number: 2011920541

For all general information contact Arcadia Publishing at:
Telephone 843-853-2070
Fax 843-853-0044
E-mail sales@arcadiapublishing.com
For customer service and orders:
Toll-Free 1-888-313-2665

Visit us on the Internet at www.arcadiapublishing.com

To my best friend, my angel, my wife, Sharon

CONTENTS

ACKNOWLEDGMENTS

Thanks go to Dorothy Weiner-Ruhe (my Aunt Dot), for insisting that I get involved with collecting Bethlehem postcards, as she shared my love for the history of Bethlehem; Julia Maserjian, for showing me the importance of the postcards and for her assistance in helping me find the right people to publish this book; Dave Rider, for his endless support in computer technology; Jane Gill, for her vast knowledge of historic Bethlehem, her attention to accuracy, and fantastic proofreading; Phil and Norma Beck; Danny Horninger; Marge Blatnik Billheimer; Jack Phelps; Tim Gilman; Hub Wilson; Angelo Caggianno; Keith Rust and Leonard Barkis, for their Lehigh University and *Brown and White* expertise; Lanie Graf and Paul Peucker, of the Moravian Archives, Bethlehem, Pennsylvania; the Bethlehem Area Public Library; and the Lehigh Valley Postcard Club.

Thanks also to my family, friends, and acquaintances who shared my enthusiasm every time I acquired yet another postcard to add to the collection.

And finally, I would like to thank my coauthor, Karen Samuels, for her skillful writing that helped every postcard in this book tell its own story.

Unless noted in the caption, all postcards in this book are from Bill Weiner's collection.

—William G. Weiner Jr.

INTRODUCTION

Postcard collecting, or deltiology, is still an immensely popular hobby worldwide. Most collectors have a special type of postcard they search for. It might be fire stations, trolleys, and so on. For Bill Weiner, it was the hunt for any postcard pertaining to his hometown of Bethlehem, Pennsylvania. Over the years, he amassed an amazing collection. Soon, Bill realized that his postcards of the schools, mills, and street views told the history of Bethlehem.

Through collecting postcards, Bill discovered a Bethlehem photographer who took clear and artistically composed photographs in the early 1900s. He came to know the man's work so well that he could spot one of his photographs without seeing his name printed on the card. The photographer was Gustav Adolph Conradi, who was born in Bethlehem in 1867 to Adolph and Clementine Caroline (Eberlen) Conradi. The family, including older sister Lulu, observed the Moravian faith and was active in the community. Adolph was a barber with a shop located at 1 West Broad Street. As a young man, Gustav was an apprentice barber under his father. Gustav married Emma M. Kuntz in 1892, and the couple lived at 67 West Broad Street. By the time of his marriage, Gustav was self-employed as a commercial photographer. His business was located at Broad and New Streets, across from the American House. In the 40-odd years that Gustav was a photographer, he captured images that documented all aspects of life in Bethlehem. His photographs appeared in the *New York Times* and *National Geographic* magazine. Gustav took a series of photographs of the 1910 Bethlehem Steel strike. When Charles M. Schwab, president of the company, learned about the postcards, he attempted to purchase all of them to remove them from the public; seven of these rare postcards appear in this book. Conradi died March 1, 1933, and was buried in Nisky Hill Cemetery.

Conradi was publishing postcards at the height of their popularity. The history of postcards in the United States can be traced back to the first popular postcard printed in 1861 by John P. Carlton, of Philadelphia. The copyright was later transferred to H.L. Lipman. And the cards became known as Lipman postal cards. The US government postals replaced them in 1873. The 1893 Columbian Exposition in Chicago inspired the first postcards printed as souvenirs. Postcards really took off when in 1898 the US government permitted privately printed postcards to be mailed for 1¢, the same rate as the government postals. Personal comments could only be written on the picture side of the card. In 1901, the government permitted writing on the undivided back of the postcard; six years later, a divided back was permitted, allowing the front of the postcard to be devoted entirely to the picture. The US Post Office counted 677,777,789 postcards mailed in 1908, while the population of the country that year was 88,710,000. White-border cards became popular from 1916 to 1930. A change to linen-type paper resulted in more vivid colors from 1930 to 1945. Photograph reproductions became clearer with the photochrome process in 1939. Photochrome continues to be used today.

The postcards in this book show that Bethlehem was a fascinating place. The earlier history of the Moravian settlement of Bethlehem, founded in 1741, greatly influenced what Bethlehem later became in the 20th century. The Moravians initially worked in a communal system to support their missionary endeavors. The group was so successful that within 20 years, they had established over 50 industries. Their success attracted non-Moravians as customers, tourists, and workers. In 1844, the Moravian Church congregation decided to open their community to everyone, and Bethlehem became a typical American town.

The Moravians had purchased several tracts of land on the south side of the Lehigh River. In 1848, they sold four farms to Charles A. Luckenback. This was the beginning of the development of South Bethlehem. In 1863, the Bethlehem Iron Company completed its first blast furnace and rolling mill in South Bethlehem. In 10 years, the enterprise became the first in the United States to use the Bessemer system to produce steel. In 1889, Bethlehem Iron Company accepted contracts from the US Navy. The company was reorganized as the Bethlehem Steel Company in 1904, with Charles M. Schwab as president. South Bethlehem became a borough in 1865. Immigrant workers—first German and Irish, later Czech, Slovak, Hungarian, Windish, Polish, and Italian—flocked to South Bethlehem to find jobs in the many industries. Bethlehem and South Bethlehem consolidated in 1917. It was an exciting time. People arrived by train every day, looking for work. There was a housing shortage, and as a result, new buildings were going up on every available lot. This is the Bethlehem you will view through the postcards in this book.

Working on this project with Bill has been a wonderful adventure. I was unaware of the existence of many of the postcards that appear in this book. Through writing the captions, I had the opportunity to explore Bethlehem history in greater detail. These postcards chronicle a way of life that has vanished. In them, we see buildings that have since been demolished, means of transportation that no longer exist, and the long-gone bustling shopping centers of Main and Third Streets. The South Bethlehem Market House, Broughal School, the amusement parks, and the Central Fire and Police Station were all razed. Because of photographers like Conradi, we can look at these images to discover our local history. Bill's passion of collecting Bethlehem postcards has allowed us to revisit this amazing history.

—Karen M. Samuels

One

MORAVIAN

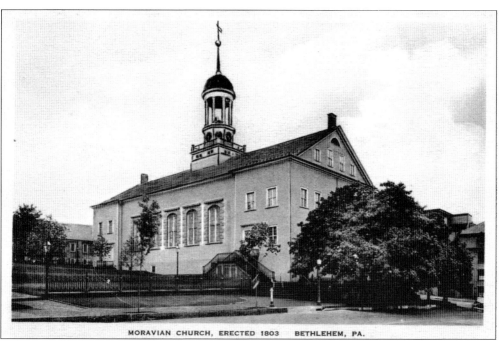

MORAVIAN CHURCH, ERECTED 1803 BETHLEHEM, PA.

The congregation of the Moravian Church in Bethlehem had outgrown the space in the Old Chapel. Work began on a new church building in 1802; two log buildings were cleared on the selected site, and stone was quarried that winter. On April 16, 1803, the cornerstone was placed at the northwest corner of the building. When completed, it was the largest church building in Pennsylvania at that time, with a final cost of $52,000.

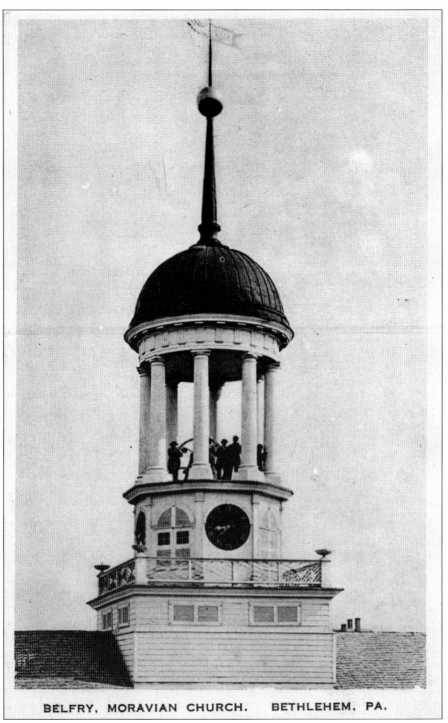

BELFRY, MORAVIAN CHURCH. BETHLEHEM, PA.

The trombone choir traditionally played from the belfry of Central Moravian Church to summon the congregation. They played to signal the death of a community member, for funerals, and for Sunday services and holy days, such as Christmas, Lovefeasts, and Easter Sunrise. The trombone choir was usually made up of the soprano, alto, tenor, and bass instruments.

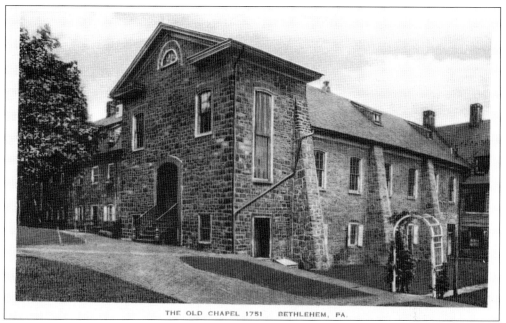

THE OLD CHAPEL 1751 BETHLEHEM, PA.

The Old Chapel, built in 1751, was the second church for the Moravians. The timber for the structure was milled in Lehighton and floated down the Lehigh River to Bethlehem. The building was an addition to the Gemeinhaus, which was a meeting place for Colonial leaders. The Old Chapel's first floor was the living quarters for the married couples, and the chapel was on the second floor.

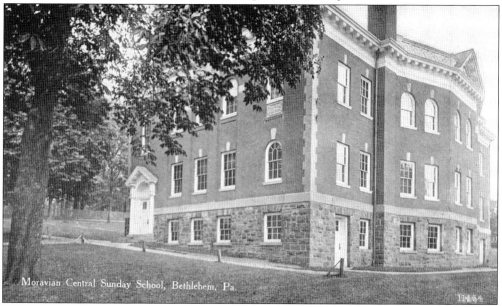

Moravian Central Sunday School, Bethlehem, Pa.

The caption indicates that this postcard shows a Sunday school; however, the Moravians built this school in 1857 to serve the newly consolidated boys' and girls' day school. The four-story brick building cost $20,000 to erect and was called the Moravian Parochial School. The upper story was used for concerts and lectures. On October 16, 1871, Samuel Langhorne Clemens, better known as Mark Twain, spoke to a sold-out crowd in the school. Today, the building serves as the Moravian Elementary School.

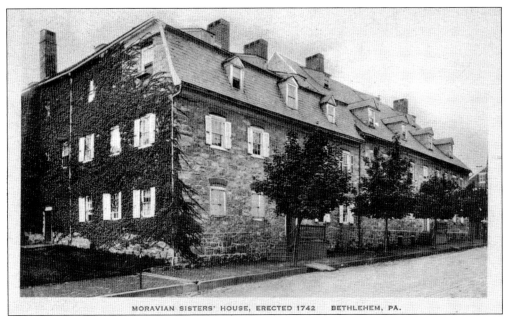

MORAVIAN SISTERS' HOUSE, ERECTED 1742 BETHLEHEM, PA.

Count Zinzendorf selected the site of this building in 1742; however, it was not erected until 1744. The large stone structure served as home to the single Moravian brothers until 1748. At that time, the single women moved into the building. The edifice held their dormitories, chapel, dining room and kitchen, and crafts workshop areas. During the Communal System (1745–1762), congregation members placed their girls, at the toddler age, into the care of the unmarried women in the Sisters House. The building remained a women's residence for 250 years.

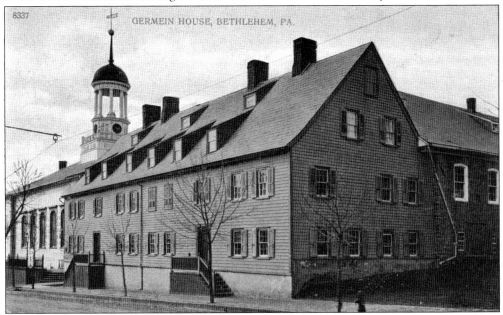

GERMEIN HOUSE, BETHLEHEM, PA.

This community building was constructed of logs in 1741. It was the center of life in the early Moravian community. The members worshiped in the Saal, or meeting room, on the second floor. The building provided living spaces for men and women. The Gemeinhaus served as a meeting place for Colonial leaders such as George Washington, Benjamin Franklin, and General Lafayette.

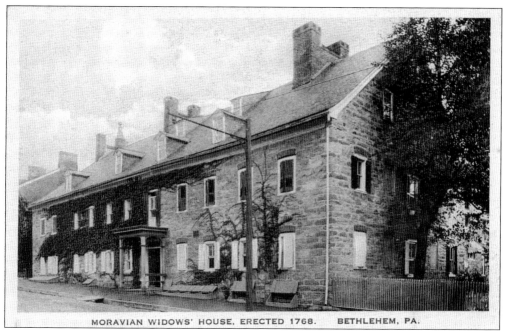

MORAVIAN WIDOWS' HOUSE, ERECTED 1768. BETHLEHEM, PA.

The Widows' House was the last of the choir houses to be built. Upon completion in 1768, it formed the fourth side of the Bell House Square, now intersected by Church Street. On October 12, 1768, a group of 30 Moravian widows walked from their previous residence in Nazareth to their new home in Bethlehem.

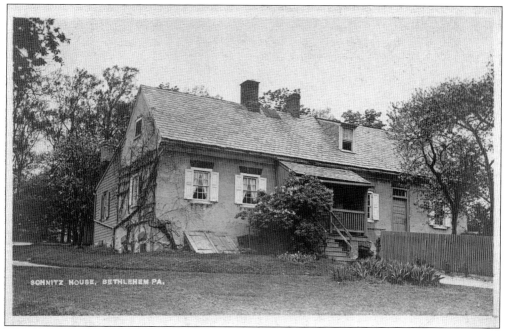

SCHNITZ HOUSE, BETHLEHEM PA.

The Schnitz House on Church Street acquired its name because the sisters and brothers gathered there annually to prepare the village supply of *schnitz* (dried apples). It is a small plaster cottage built behind the Bell House in 1749. It is of log construction, and a large orchard of apple trees once surrounded the house.

13

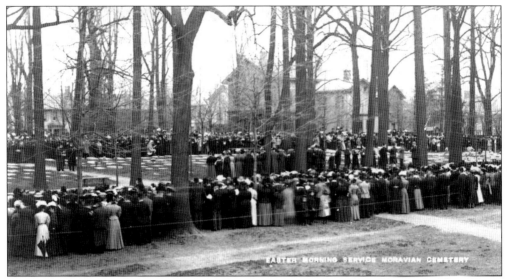

Since 1752, it has been a custom of the Moravian Trombone Choir to walk the streets of Bethlehem, playing chorales before dawn to summon the members of the church to the Easter service. After the sermon, the members proceed to God's Acre. Just as the group enters the cemetery, the sun is dawning. The simple custom became a popular tourist attraction in the early 1900s. Many of the people in this crowd are not of the Moravian faith. They are just curious folks who have arrived by trains and trolley cars to observe the ceremony.

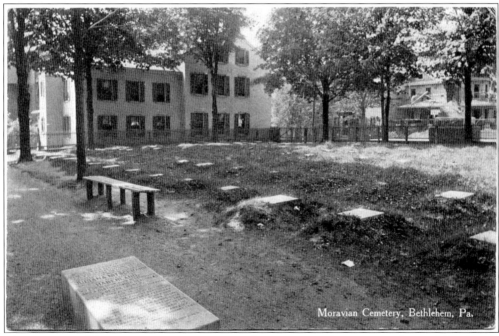

This is a view of the Moravian Cemetery, or God's Acre, on Market Street. Bishops of the church, Indians, missionaries, teachers, soldiers, generals of the American Revolution, and others are buried there. The markers are identical in their simplicity. The first grave was dug in 1742 for John Mueller.

Two

BETHLEHEM STEEL

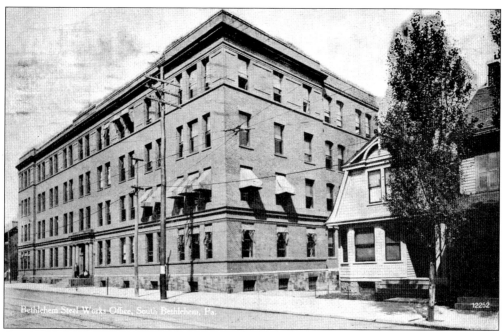

This is a view of the Bethlehem Steel Company's main office around 1914. The building began as a farmhouse and had several additions over the years, reflecting the growth of the company. On July 16, 1861, ground was broken for the first blast furnace in the Bethlehem area. In the planning stages, the company was known as the Saucona Iron Works. As the first blast furnace went into operation, it became the Bethlehem Rolling Mills & Iron Co. In 1904, Charles M. Schwab organized the company as the Bethlehem Steel Company.

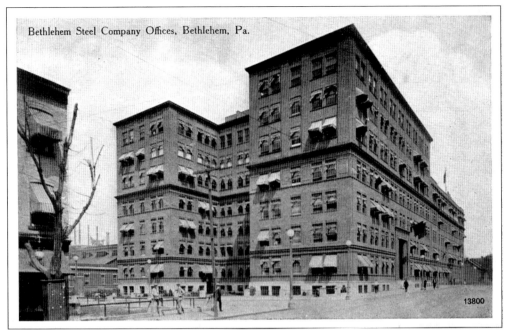

Bethlehem Steel Company Offices, Bethlehem, Pa.

13800

In 1906, Charles M. Schwab added a front section to the Bethlehem Steel headquarters on Third Street. In 1921, he added additional floors, making it a 13-story building. Luxurious dining rooms were created for each of the division executives. A doorman and a pretty, young female escort guided visitors to their destinations. The building, donated by philanthropist Linny Fowler, is now a satellite campus for Northampton Community College.

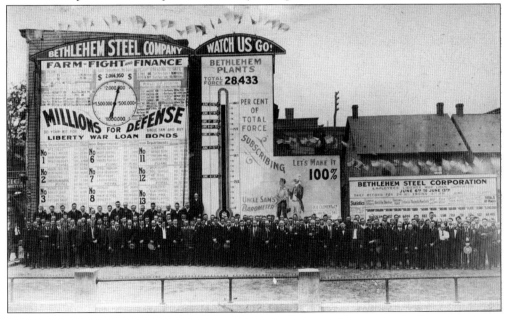

The Bethlehem Steel Company conducted an aggressive campaign to persuade its employees to buy war bonds during World War I. As this photograph illustrates, a tally was kept of bonds purchased by each department. The giant sign indicates that 28,433 employees raised more than $2 million in bond sales.

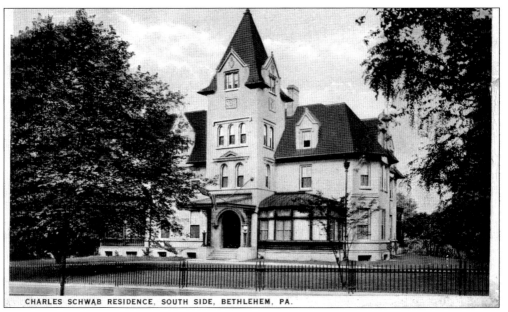

CHARLES SCHWAB RESIDENCE, SOUTH SIDE, BETHLEHEM, PA.

Charles M. Schwab (1862–1939) incorporated the Bethlehem Steel Company on December 10, 1904. He purchased the 1870 Linderman mansion at 557 West Third Street, Fountain Hill. A cut-granite tower rose to three stories. The front door was centered in the tower and was topped by an iron entry canopy. The iron motif is echoed in the details of the porch and conservatory's facade. The building has been converted into several apartments.

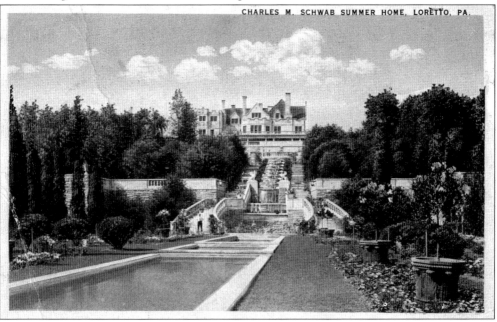

CHARLES M. SCHWAB SUMMER HOME, LORETTO, PA.

Charles M. Schwab was raised in Loretto, Pennsylvania. After becoming a wealthy man, he returned to Loretto to build a 44-room summer estate on 1,000 acres. He called his estate Immergrün, German for "evergreen." The house featured opulent gardens and a nine-hole golf course. Schwab's estate sold Immergrün after his death, and it is now Mount Assisi Friary on the grounds of Saint Francis University.

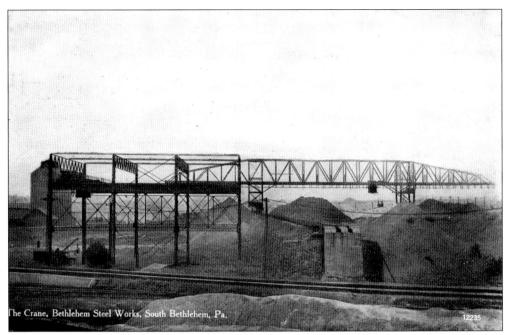

The Crane, Bethlehem Steel Works, South Bethlehem, Pa.

Today, this giant ore bridge (crane) has been kept intact in front of the Sands Casino. This view of the crane shows iron ore stockpiles in the foreground. The track in front of the crane once was used by freight trains. The crane transferred ore from the trains and loaded it onto conveyor belts.

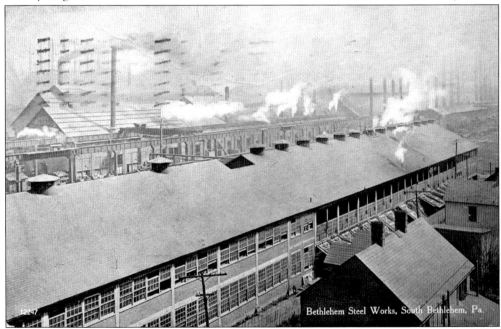

Bethlehem Steel Works, South Bethlehem, Pa.

The key to the Bethlehem Steel Company's success for so many years was in the updating of its technology and processes. Pre-1900 updates included the building of the open-hearth furnaces, improvements in automatic handling in the rolling mills, the adoption of the Whitworth forging press, the manufacture of armor plate, the application of the Bessemer process in steel making, and the erection of a 125-ton steam hammer.

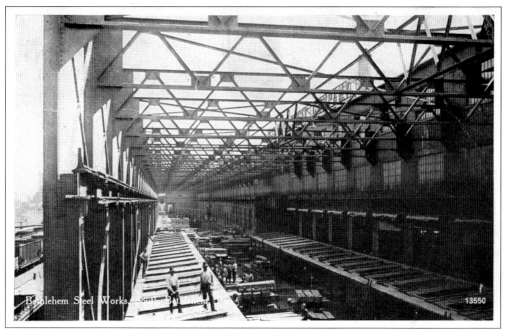

In this view, Bethlehem Steel workers are dwarfed by the giant structures of the mill. Immigrants of Czech, Slovak, Hungarian, Windish, Polish, Italian, Armenian, Greek, Mexican, Portuguese, and Spanish heritages came to the United States in the early 1900s seeking employment. At this time, over 22 percent of the population of Bethlehem was foreign-born.

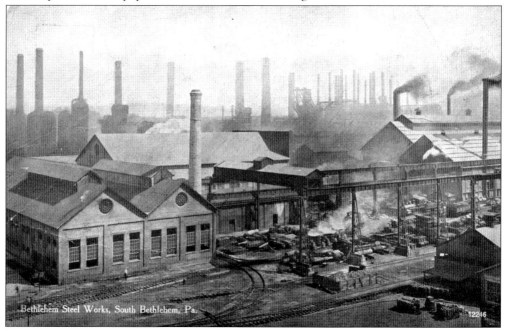

In this view, the open structure is a part of the ore yard. This is where the raw materials for the open-hearth furnaces were received on elevated railroad tracks. A total of seven interconnected rail yards on Bethlehem Steel property joined the coke plant to the foundry buildings. The Philadelphia, Bethlehem & New England Railroad, a subsidy of Bethlehem Steel, ran the rail lines.

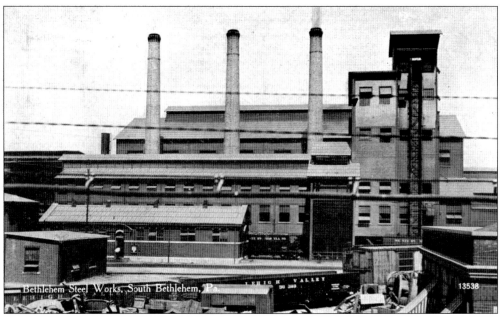

This is a view of the No. 3 open-hearth shop in 1910. Bethlehem Steel demolished it with explosives in 1988. Open-hearth furnaces operated by burning off excess carbon and other impurities from pig iron to produce steel. Bethlehem Steel replaced its open-hearth furnaces with a basic-oxygen furnace.

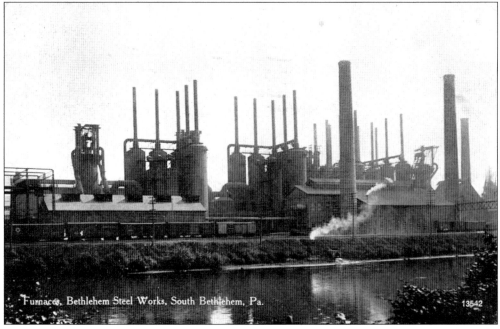

This is the Bethlehem plant of the Bethlehem Steel Company. The blast furnaces are seen along the Lehigh River. The location along the river was important to the iron and steelmaking processes. The plant's processing systems used more than one million gallons of water a day. It required 65,000 gallons to make a single ton of finished steel. The bed of the Lehigh River still contains high concentrations of cadmium and zinc from this industry.

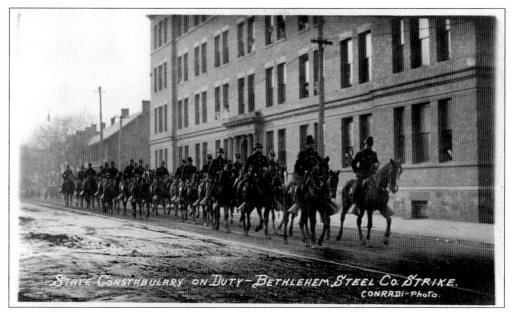

The Bethlehem Steel workers strike of 1910 began when one worker refused to work overtime on a Sunday. The shop foreman fired him. The other machinists in the shop formed a committee and requested a meeting with the foreman to make an appeal for the reinstatement of their coworker. These employees were also fired. A strike was called on February 10, 1910, and 2,000 workers eventually joined. (Courtesy of Moravian Archives, Bethlehem, Pennsylvania.)

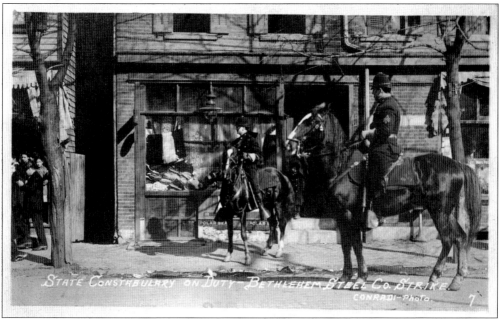

There were several conflicts between the strikers and the men who continued to work. Bethlehem chief of police Hugh Kelly contacted Northampton County sheriff Robert Person, as he felt his men could no longer control the crowds of strikers. The sheriff appealed by telegram to Gov. Edwin Sydney Stuart to send the newly created Pennsylvania State Police. This uniformed police organization, created in 1905, was the first of its kind in the United States.

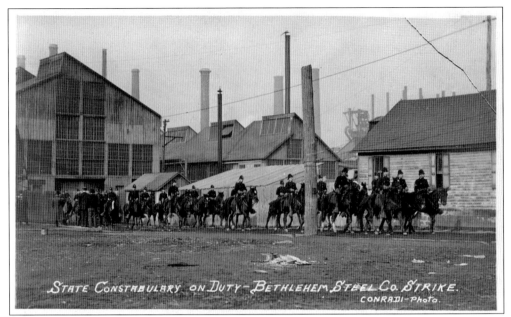

On February 26, 1910, a group of 21 members of the state police arrived in South Bethlehem from Philadelphia. They were assigned to guard the gates to the steel mill. During the day, crowds of strikers continued to gather at the gates, and the violence escalated. The state police used riot sticks and fired their pistols into the air to disperse the strikers. (Courtesy of Moravian Archives, Bethlehem, Pennsylvania.)

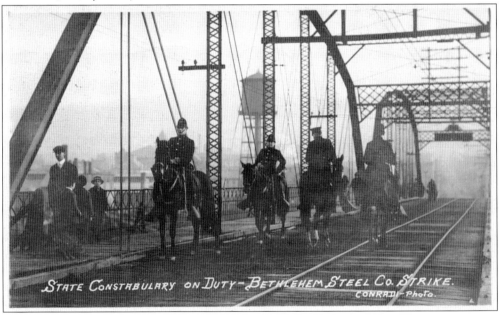

The Pennsylvania State Police was created by legislation signed into law by Gov. Samuel W. Pennypacker on May 2, 1905. The department became the first uniformed police organization of its kind in the United States. Only single men could join the force. In 1915, labor leaders testified to the US Commission on Industrial Relations that they felt the state police were pro-management during the strike in Bethlehem.

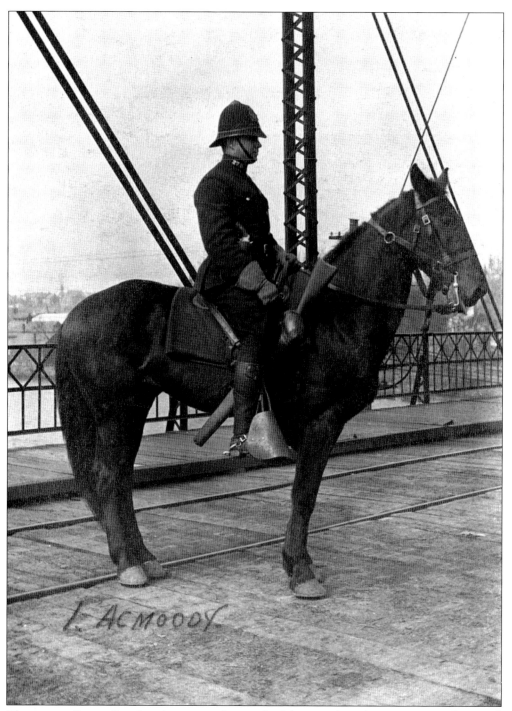

LACMOODY

The state police preferred to be mounted on trained horses when they met an unruly crowd. They felt they could move more swiftly on horses than on foot. When the state police rode into Bethlehem on February 26, 1910, the crowd along Third Street jeered them. The police presence encouraged a growing number of men to return to work during the strike. The strikers were never able to affect the productivity of the mill, and the strike ended on May 18, 1910.

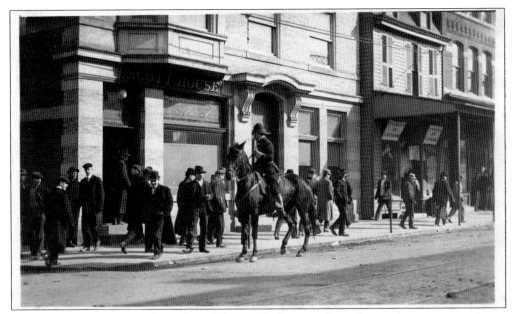

The presence of the state police inflamed the conflict between the strikers and management. A state policeman fired his pistol into the crowd, wounding a striker in the leg. John Moughan, another state trooper, rode his horse onto the sidewalk in front of the Majestic Hotel, located half a block from the main office of the mill. The hotel was a known meeting place for the union organizers. He fired two shots into the hotel barroom. A striker, Joseph Szambo, was in the barroom buying wine for his wife who had just given birth. The shots killed Szambo and hit another striker in the mouth.

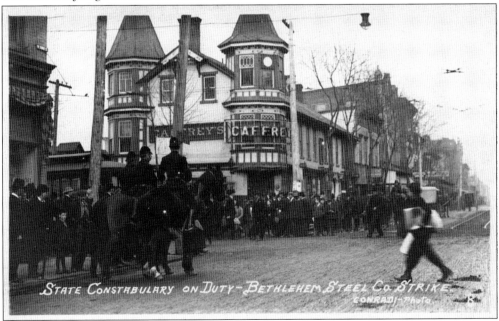

This is a view of the intersection of Third and New Streets. T.C. Caffrey operated a hotel on the corner. The strike attracted thousands of sightseers, who clogged the streets of South Bethlehem. On May 18, 1910, a total of 103 days after the strike began, workers accepted Charles M. Schwab's offer of optional overtime and Sunday work, without wage increases, and the strike ended.

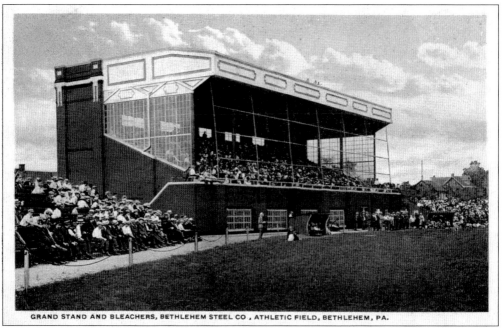

GRAND STAND AND BLEACHERS, BETHLEHEM STEEL CO., ATHLETIC FIELD, BETHLEHEM, PA.

The Bethlehem Steel Company athletic field was built in 1913 as the country's first soccer field with stadium seating. It was built for the Bethlehem Steel Soccer Club (1913–1930), the most-winning soccer team in US history. The stadium was located on Elizabeth Avenue. Today, this athletic field is owned by Moravian College and used by their football team.

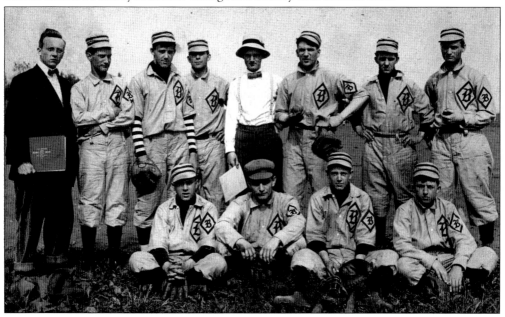

In 1917, Bethlehem Steel established an internal baseball league among six of its East Coast plants. Initially, local workers filled the rosters. The players participated only on their days off, Sundays, and holidays. By the following year, plant executives started bringing in ringers for their teams. It was not difficult to find top talent. Major and minor league players were receiving draft notices to join the war effort. Ballplayers either had to enlist or find employment in a war-related industry.

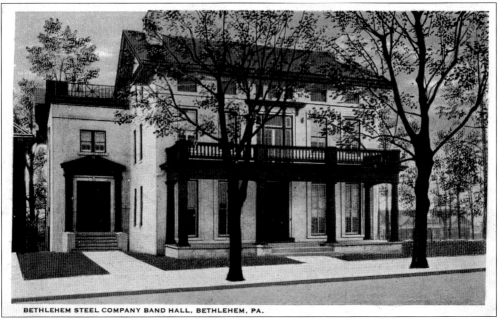

BETHLEHEM STEEL COMPANY BAND HALL, BETHLEHEM, PA.

In 1910, Schwab purchased the Weaver home, at 11 West Market Street, for the headquarters of the new Bethlehem Steel Company band. In 1925, Bethlehem Steel donated the building to the city for the use of the Bethlehem Public Library. After the library moved to its new building in 1968, this was the home of the Bethlehem Chamber of Commerce. Today, it is owned by Moravian Academy.

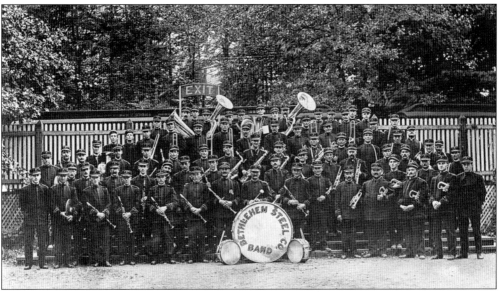

The Bethlehem Steel Company Band performed its first concert on December 22, 1910, as a Christmas present to the community from Charles M. Schwab. He was attempting to clean up his image and boost morale after the strike earlier in the year. The band was nicknamed "Schwab's Band" and frequently gave free concerts at public events. It was composed of 60 men employed in the plant. Andre M. Weingartner was the band director. The band was non-unionized, and unionized bands refused to perform with them at the same venues. This led to the breakup of Schwab's Band in 1925.

Martin Tower, built between 1969 and 1972, is the tallest building in the Lehigh Valley. The 21-story skyscraper was named for chairman and chief executive officer Edmund F. Martin. Over 15,894 tons of structural steel was used in its construction. The exterior of the tower was faced with approximately 1,500 panels of porcelainized steel plate, each painted gray and beige. This monument of a building could not reverse the decline of the company. Operations in Bethlehem ended November 18, 1995. The building served as central headquarters from 1972 to 2001.

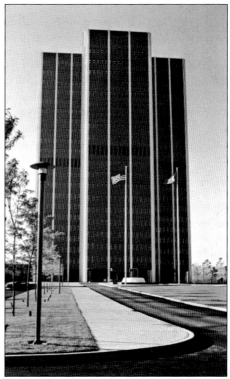

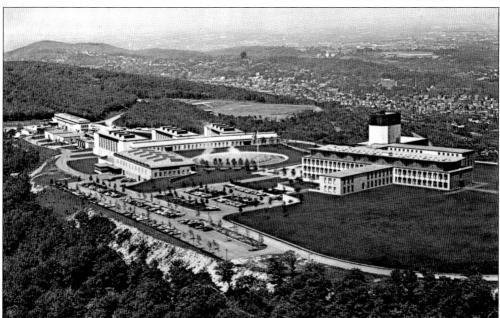

Bethlehem Steel Homer Research Laboratories was once the world's largest steel research facility. It opened in 1961 and was named for former Bethlehem Steel chairman Arthur B. Homer. The eight buildings on 1,000 wooded acres atop South Mountain cost $25 million to build. Nearly 1,000 scientists and engineers were employed there to develop new products. The property was sold to Lehigh University in 1986, and the International Steel Group took over the lab in 2001.

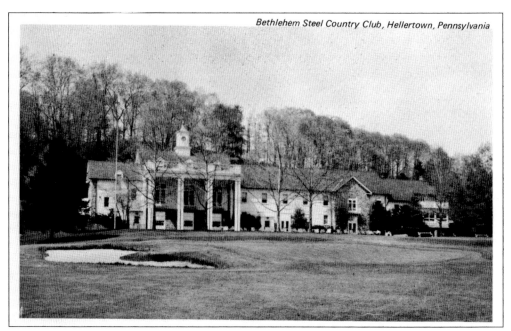

Bethlehem Steel Country Club, Hellertown, Pennsylvania

In 1947, the Bethlehem Steel Corporation built a recreational facility just outside Hellertown for its plant management personnel. An 18-hole golf course was laid out by Donald Ross, a well-known golf course architect. A group of its members purchased the club from Bethlehem Steel in 1986, and the club became known as Silver Creek Country Club.

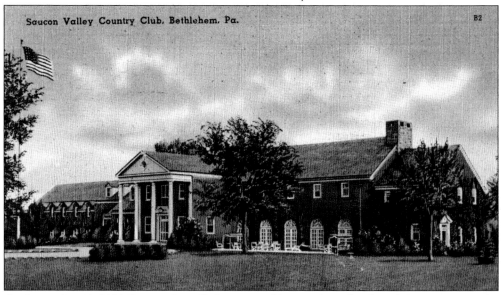

Saucon Valley Country Club, Bethlehem, Pa. B2

On September 14, 1920, Eugene Grace led a group of 16 prominent local residents to organize the Saucon Valley Country Club. Many in the group were Bethlehem Steel Corporation executives. They agreed to purchase the 208-acre Grim farm for $24,600. The property, located near Friedensville, was a lovely farm with the Saucon Creek winding through the grounds. The Grim family home soon became the clubhouse. The former chicken house became the locker house. The Saucon Valley Country Club went on to acquire three other family farms (Bahl, Gangewer, and Albright) to create 700 acres of world-class courses.

Three

SCHOOLS

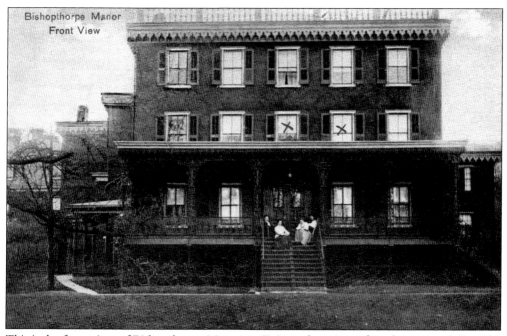

This is the front view of Bishopthorpe Manor, an Episcopal seminary for select young ladies. The name *Bishopthorpe* meant "a Bishop's demesne or estate." The school opened in 1868 in a mansion purchased by Tinsley Jeter. In 1930, St. Luke's Hospital purchased the building to house its nursing school. After serving 126 years as a school, St. Luke's Hospital razed the building in 1994.

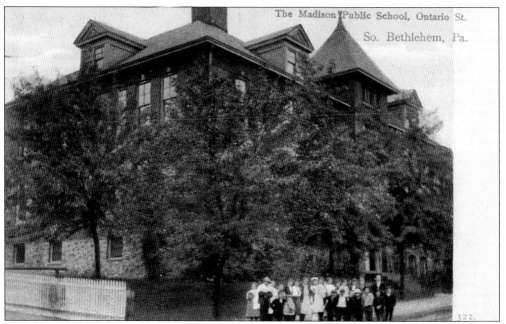

The Madison School was built in 1888, at a cost of $13,000, to replace the Wyandotte Street School. Architect A.W. Leh designed the school. It was located at 707 Ontario Street, south of Wood Street, near Itaska Street. A large addition was erected in 1902 at a cost of $7,845. Students pose with their teacher in front of the school, which was eventually demolished.

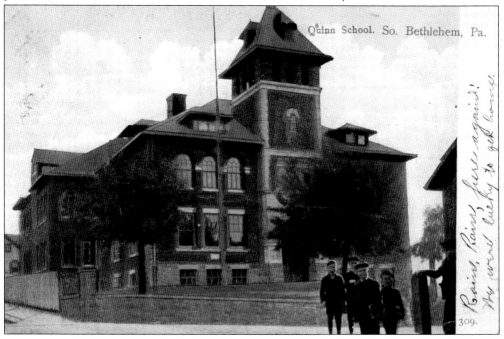

Named for school director Charles Quinn, the Quinn School was built in 1902 at a cost of $29,560. At the Quinn School, so-called Americanization classes were taught (1915–1920) to assist the new immigrants employed by Bethlehem Steel Company in adjusting to life in the United States. The Quinn School burned in 1920 and became a parking lot for Bethlehem Steel.

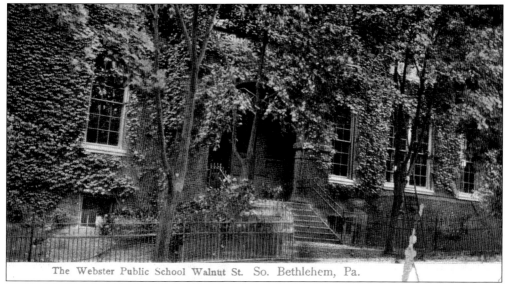

The Webster Public School Walnut St. So. Bethlehem, Pa.

The Webster School was built in 1889 at a cost of $24,000. It was an eight-room, brick structure situated on the east side on Carlton Avenue, south of Packer Avenue and north of Broadway. School custodian Pappy Hefflefinger was a Pennsylvania Dutch powwow doctor, or shamanic healer. If a student asked Pappy to treat their warts, he would ask them for a penny. He would say a prayer over the penny and that night, the child would sleep with the coin under their pillow. The warts would be gone the next day.

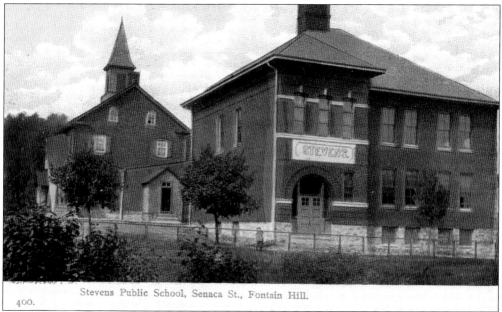

400.

Stevens Public School, Senaca St., Fontain Hill.

The Jeter School was built in 1880 as a four-room school, measuring 40 by 80 feet. It was a two-story, brick building on Seneca Street. In 1905, the school was renovated to include an east wing, a main hall, and four rooms. At the time, it was renamed the Stevens School. In 1916, another wing was added to Stevens School, at a cost of $10,000, and the building now included a high school. The original Jeter building was razed in 1918. A 75-unit apartment building for senior citizens was built on the site in 1982.

31

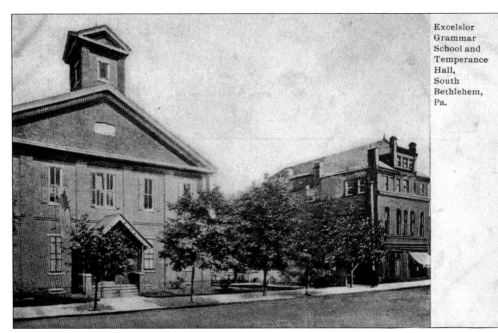

Excelsior Grammar School and Temperance Hall, South Bethlehem, Pa.

The new Excelsior School was built in 1879 for $17,100. It was located on Fourth Street, between Birch and Elm Streets, and served as a four-year high school from 1879 to 1892. The high school program then moved into Central High School in 1892.

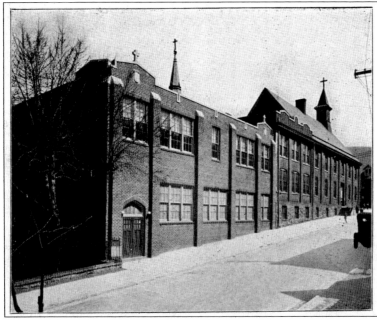

School of St. Cyril & Method, Bethlehem, Pa.

The School of SS Cyril and Methodius, located at 551 Thomas Street, became a school in 1907. The SS Cyril and Methodius Church parishioners built their first church in 1891. The Slovak population in Bethlehem grew, and they soon needed a bigger church, which they built in 1906. The first church was converted into the school seen here. The school was closed in 2006 when a merger of three parochial schools occurred. Today, the old school building is rented to the Bethlehem Area School District.

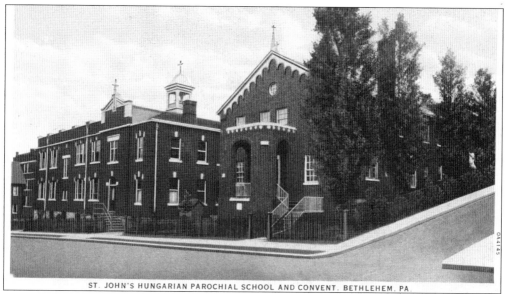

ST. JOHN'S HUNGARIAN PAROCHIAL SCHOOL AND CONVENT, BETHLEHEM, PA.

In 1910, the Hungarian Catholic community of Bethlehem built their second place of worship—a combination church, convent, and school—at Fourth and Hayes Streets. On the date the new church of St. John Capistrano was consecrated, the members celebrated an elaborate ethnic and religious ceremony including sermons conducted in six languages. The delegation of the Austria-Hungary consulate was in attendance. The school closed in 1981 and was demolished in 1989 to create a parking lot for the church.

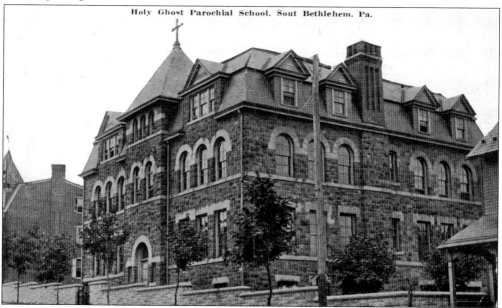

German Catholic parishioners of the Holy Ghost Church built this school, on Montclair Avenue, in 1900. It was designed by architect A. W. Leh and was described as an eclectic blend of Romanesque and Victorian attributes. When the school opened in September 1900, seven Franciscan sisters undertook the instruction of 325 students. The Holy Ghost School merged with St. Ursula's School to create the Holy Child School in the 1980s. The Bethlehem Area Public School District rented the old school for kindergarten classes for several years.

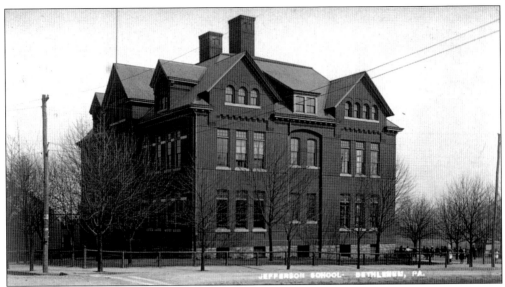

Named for Pres. Thomas Jefferson, the Jefferson School was built in 1890, at 506 North Street, for $26,354. Bishop and Fatzinger Construction Company was granted the contract to build it. At the time it was built, male teachers received an average salary of $540, and female teachers received $120 annually.

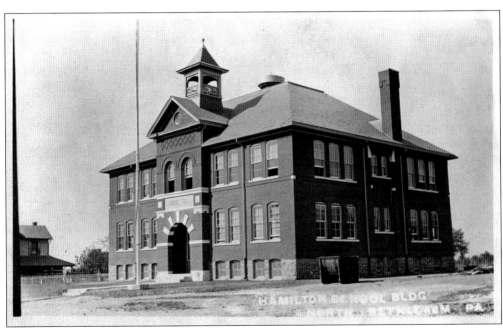

North Bethlehem Township, annexed to Bethlehem in 1918, included three schools: Monocacy School, Fox School, and Hamilton School, located at the corner of Hamilton Avenue and Linden Street (pictured here). The Hamilton School was built in 1909 by William F. Danzer and designed by A.W. Leh. In 1972, the Bethlehem Area School District closed Hamilton School. Today, it is leased from the district by the Sayre Child Care agency. (Courtesy of Norma Beck.)

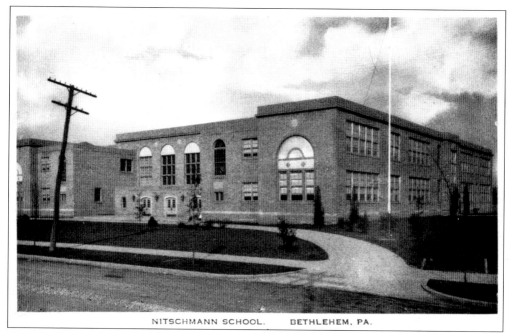

NITSCHMANN SCHOOL. BETHLEHEM, PA.

The Nitschmann School at Eighth Avenue and West Union Boulevard was constructed in 1920 for $376,000. It was built on the west side of Bethlehem because of the increase in population at the time. It has served as a junior high school and middle school.

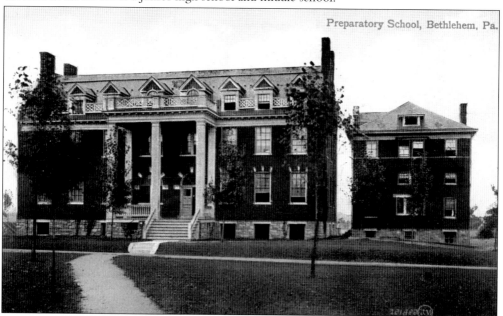

Preparatory School, Bethlehem, Pa.

Prof. William Ulrich founded the Preparatory School in 1878. It was originally called the Preparatory School for Lehigh University, with the charter class of nine students meeting in a building on Fourth Street. Ulrich succeeded as an instructor, evidenced by his students, who were accepted at Lehigh and Cornell Universities. Designed by architect A.W. Leh, the building shown in this postcard was located near the Rose Garden on Eighth Avenue. The school moved to 10 acres at that location in 1901.

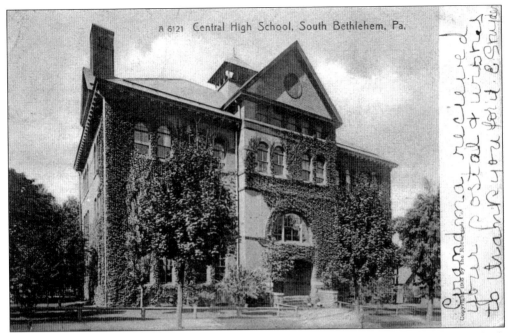

A 6121 Central High School, South Bethlehem, Pa.

When this photograph was taken, Central School was serving as a high school. When it was built in 1892, only the third floor was reserved for the high school students. The school was located at 434 Vine Street, near Church Street and University Place, on the site of the old Penrose School. It was built for a cost of $36,742 and torn down in 1967, after serving as an elementary school.

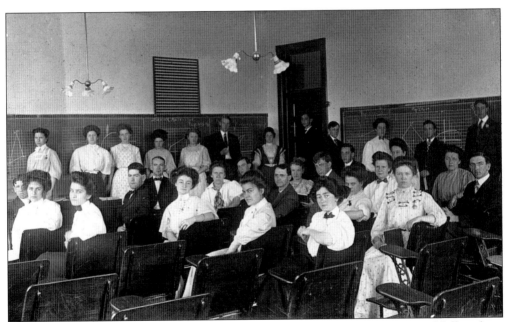

Here is a math class at Central High School in 1909. The math curriculum required "all students should have a working knowledge of the principles of graphical construction." The hard academic work did not prevent the girls from wearing Gibson Girl hairstyles and the boys from sporting tall, stiff collars and sack coats.

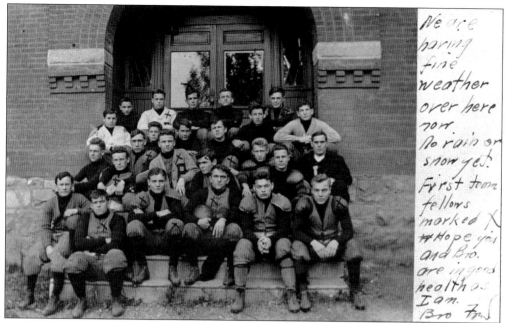

We are having fine weather over here now. No rain or snow yet. First team fellows marked X Hope you and Bro. are in good health as I am. Bro Frd

Pictured is the boys' football team of Central High School. Their uniform included leather shoulder pads, leather high-top football shoes with wooden cleats, and knit socks with stirrups. This team played in an interscholastic league consisting of South Bethlehem High School, Moravian Parochial, Allentown High School, Central High School of Bethlehem, and Easton High School.

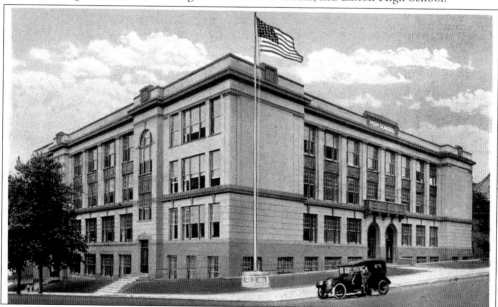

Noted architect A.W. Leh designed Broughal School—a four-story, 114,000-square-foot school building—in the Italian Renaissance style. It was built in 1915–1916, on just over four acres, on the corner of Brodhead Street and Packer Avenue. The floors were laid with terrazzo tiles. It had a pit-type gymnasium with room for 500 spectators. Located in the center of the building, the first-floor auditorium had a seating capacity of 1,300. The auditorium, with balcony, was known for its excellent acoustics. Despite much public outcry, the building was demolished in 2009.

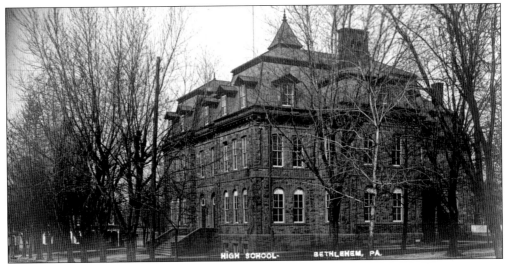

The Franklin School was located at 112 North Street, near Center Street, and opened in 1871. The land was purchased from the Moravian congregation for $1,300. The three-story building cost $66,000 to construct. In its first year, it educated 640 students. A high school class was offered in the building by 1876, and the school was expanded in 1911. The Franklin School was destroyed by fire in December 1975.

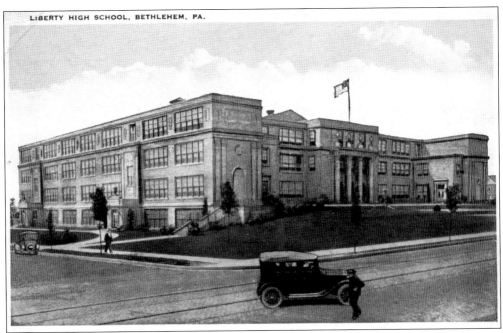

Liberty High School, originally called Bethlehem High School, was built in 1922 for $1,634,000. The Bethlehem School Board considered its location on Linden Street to be the geographical center of Bethlehem. At the time, some parents complained the school was located too far away. Bethlehem's population doubled after World War I, necessitating the building of the new high school.

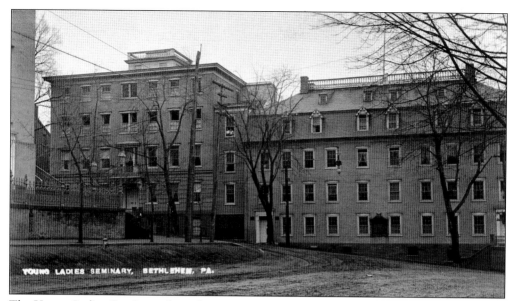

The Young Ladies Seminary (now known as Moravian College) was established in 1742 by Countess Benigna, the daughter of Count Zinzendorf. The school became the first well-known girls' boarding school in the country. It was the first school to employ a female teacher. In 1858, the Theological Seminary of Nazareth moved to Bethlehem. In 1954, the two seminaries merged to become Moravian College and Theological Seminary. This was the first coeducational college in the Lehigh Valley.

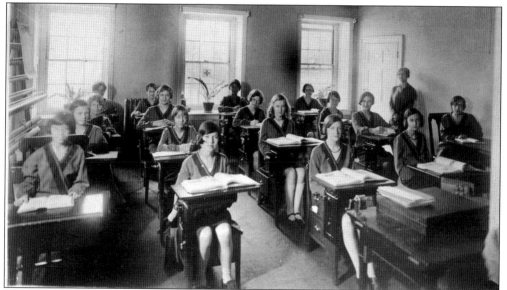

The Moravian Seminary for Young Ladies was established in 1742 and in 1954, merged with Moravian College and Theological Seminary. The young women pictured were students when the school was known as the Moravian Seminary and College for Women. Judging by the uniform and hairstyles of the students, this photograph was taken in the late 1920s. The hemline was knee-length, and the hair was cut short in bob or shingle styles. Celebrities such as Coco Chanel and Clara Bow influenced women to leave their long hair on the barbershop floor. (Courtesy of Moravian Archives, Bethlehem, Pennsylvania.)

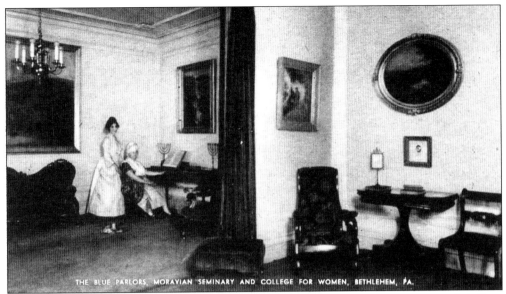

THE BLUE PARLORS, MORAVIAN SEMINARY AND COLLEGE FOR WOMEN, BETHLEHEM, PA.

Here is a view of the beautifully decorated parlor rooms of the Moravian Seminary and College for Women. On the walls were paintings by Gustavus Grunewald (1805–1878) and several other landscapes of the Lehigh Valley. Although the photograph was taken in the 1940s, two women appear in early-1900s dress; one woman is sitting at a spinet. The Moravian schools had a long history of providing excellent musical instruction. The parlors were located in the Main Hall, built in 1854. It was the first building to be lit by gas.

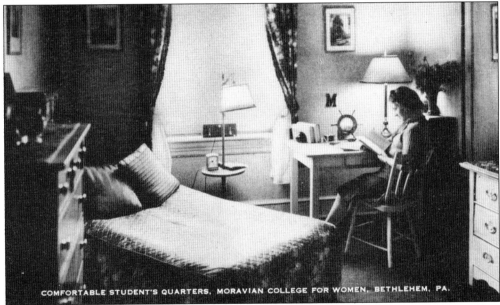

COMFORTABLE STUDENT'S QUARTERS, MORAVIAN COLLEGE FOR WOMEN, BETHLEHEM, PA.

This Moravian College student is a model of neatness in her dormitory room. This was expected of all the female students at Moravian. The rules for women in college during the 1940s covered their entire day. Students were required to study at specific times. They submitted to a daily curfew and signed out if they left the campus. Boys were not permitted to visit them in their rooms. The student had to present written permission from her parents if she wished to spend the night away from the dorm. The student dress code permitted neither slacks nor socks.

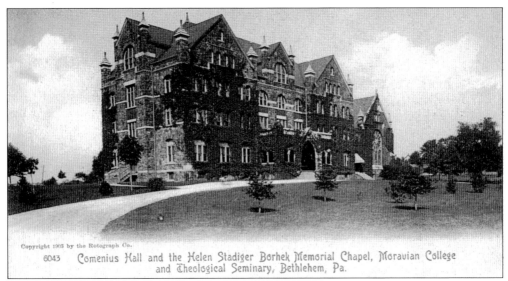

6043 Comenius Hall and the Helen Stadiger Borhek Memorial Chapel, Moravian College
and Theological Seminary, Bethlehem, Pa.

Architect A.W. Leh designed this beautiful signature building. When constructed in 1892, Comenius Hall was 110 by 60 feet and stood four stories above the basement. On the main floor were classrooms, administration, and professor offices. The upper stories were divided into suites of students' rooms. In the basement were a temporary gymnasium, a physical laboratory, and a steam plant sufficient to heat the entire group of buildings. Adjoining it to the north is the Memorial Chapel (1893), also designed by Leh. Today, Comenius is home to College Central Services office, several academic departments, and numerous classrooms

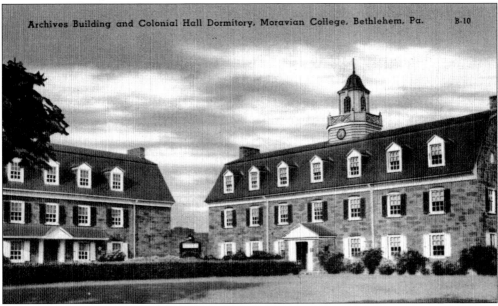

Archives Building and Colonial Hall Dormitory, Moravian College, Bethlehem, Pa. B-10

Today, Colonial Hall houses the office of the president as well as several administrative offices. The three-story stone structure was built in 1928 with a central tower and clock. The Georgian structure was originally built as a dormitory. The Archives Building on the left was erected in 1930 to house the Moravian Church archives. The archives eventually required more room, so in 1977, a building on West Locust Street was constructed. The new archive building is equipped with modern environmental controls and fire protection.

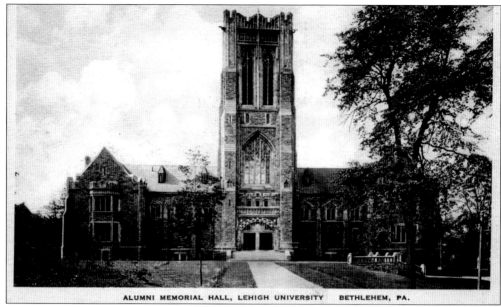

ALUMNI MEMORIAL HALL, LEHIGH UNIVERSITY BETHLEHEM, PA.

Asa Packer founded Lehigh University in 1865. He named the college after the Lehigh Valley Railroad. The University officially opened on September 1, 1866. The cost of annual tuition for the first year was $90. Alumni Memorial Hall was built in 1925, as a memorial to alumni who served in World War I. It is considered bad luck to step on the university seal engraved in the Leadership Plaza pave stones outside Alumni Memorial Hall.

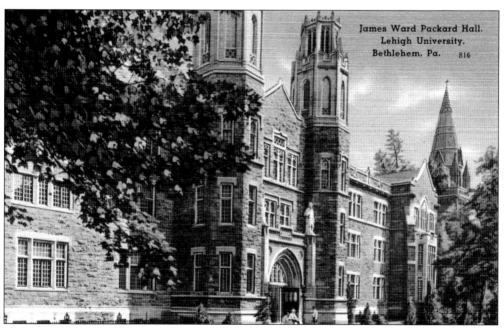

James Ward Packard Hall,
Lehigh University,
Bethlehem, Pa. B16

James Ward Packard graduated from Lehigh University in 1884 and founded the Packard Motor Car Company in 1902. He funded the costs of the laboratory building pictured here. It was completed in 1929, a year after his death. Packard donated $1.2 million to his alma mater. The building now displays the first Packard automobile, built in 1898, in its lobby.

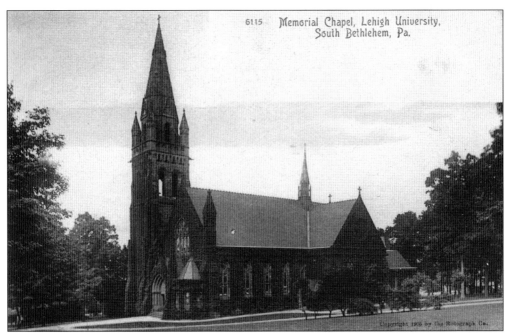

Mary Packer Cummings donated the funds to build the Packer Memorial Church in memory of her parents, Asa and Sarah Packer. Mary selected the architect Addison Hutton, of Philadelphia, to design the chapel. The entire body of Lehigh students broke ground with picks and shovels in 1885. The cornerstone was laid in 1886, and the building was completed in 1887. Packer Memorial Church hosts more than 50 alumni weddings each year.

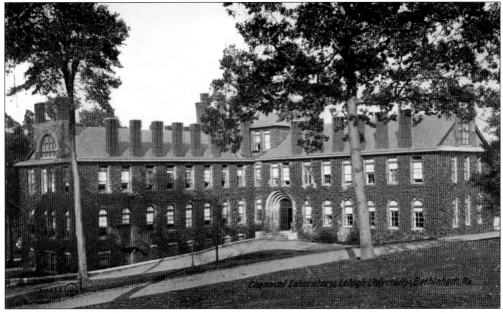

Chandler Chemistry Laboratory, now known as Chandler–Ullmann Hall, was built in 1921. William "Billy" Chandler was head of the chemistry department at Lehigh from 1871 to 1905. The structure was built in his honor and considered, at the time, to be the first modern laboratory because of its ventilation system and the design of its laboratories.

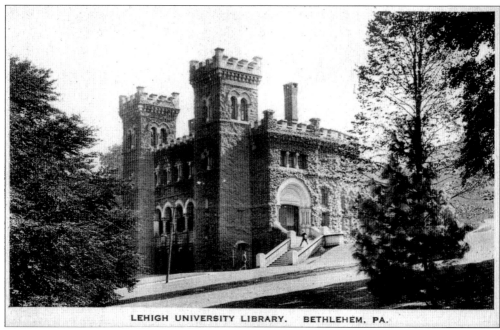

LEHIGH UNIVERSITY LIBRARY. BETHLEHEM, PA.

When Asa Packer died on May 17, 1879, he left an endowment of $1.5 million. It included $500,000 for building a library and purchasing books. Addison Hutton designed the Lucy Packer Linderman Library in memory of Packer's daughter. The library was completed in 1877, and an addition was built in 1929. Asa Packer is honored every year on Founder's Day in October.

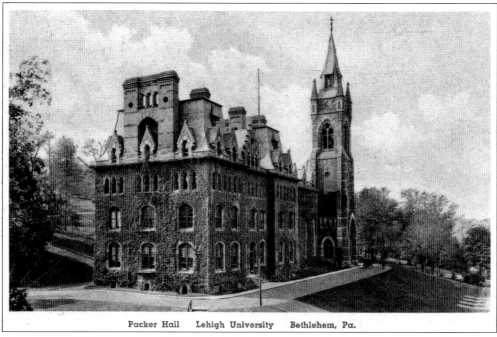

Packer Hall Lehigh University Bethlehem, Pa.

When Packer Hall was built in 1868, the Mott Street Railroad was erected on campus to carry the cornerstone directly to the site. Edward T. Potter designed the building to face the New Street Bridge. Packer Hall was enlarged in 1958 and became the University Center.

Louis Edward Grumbach, or "Grummy," was born in Massachusetts. He was a lineman on the football team and threw the discus in track and field for Lehigh University. He is wearing his letter sweater and football uniform. He was a hardworking, consistent player and gave "a wallop in every pinch," according to the school yearbook. His first job after graduating from Lehigh in 1916 was as an armaments inspector at the DuPont Powder Works in Penns Grove, New Jersey. (Courtesy of Norma Beck.)

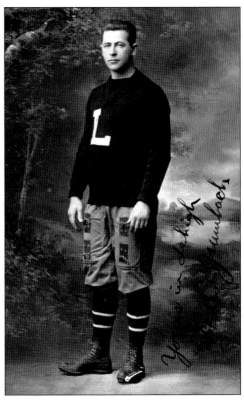

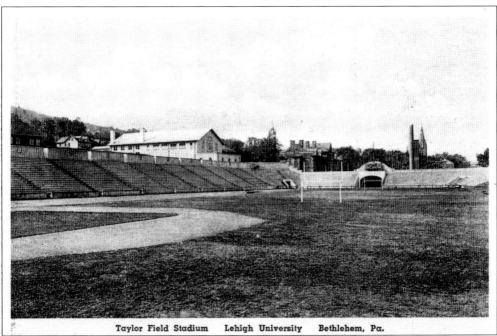

Taylor Field Stadium Lehigh University Bethlehem, Pa.

After years of petitions from Lehigh students to build athletic fields, the Taylor Stadium and athletic fields were constructed in 1914. Taylor Stadium was the third oldest collegiate stadium in the country and cost $90,000. Baseball was Lehigh's first intercollegiate sport.

45

Grace Hall was completed in 1940 to house social and athletic events. Eugene Gifford Grace graduated from Lehigh in 1899 and donated $350,000, the cost of the building. The hall was refurbished in 2003. Today, Grace Hall continues to be used for practices, intramural, club, and University events.

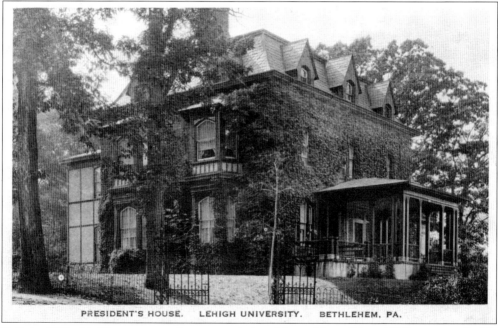

PRESIDENT'S HOUSE. LEHIGH UNIVERSITY. BETHLEHEM, PA.

Built in 1868, this 21-room stone house was designed by architect Edward T. Potter as a Gothic Revival mansion. Henry Coppee, the first president of Lehigh University, was the first to occupy the house. The first female president of the university, Alice Gast, now lives in the house with her family.

Four

COMMUNITY

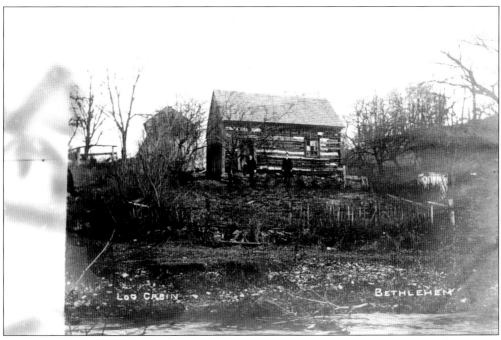

The location of this old cabin remains a mystery, and surely, it has been demolished by now to make way for a new development of houses or a shopping center. The postcard was mailed from South Bethlehem in 1909, with the message, "This is the oldest house here." There is a local story about a hermit who lived in his ancestor's cabin near the Lehigh River in the late 1800s. The hermit published a letter in the Globe Times in 1880, complaining that the hard winter made game scarce. He was therefore forced to get provisions from town, and while he was out, he visited a few neighbors to sample their home brews.

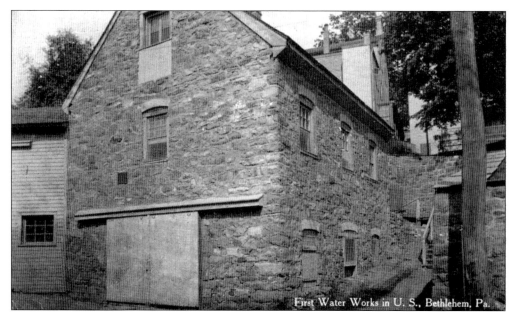

First Water Works in U. S., Bethlehem, Pa.

The first municipal water-pumping system in the United States was built in Bethlehem along the Monocacy Creek in 1754. Johann Christopher Christensen designed the ingenious system. The water was pumped through hollow hemlock logs, up the steep bank of the Monocacy, to a water tower. The water then flowed to cisterns throughout the community. During the later part of the 18th century, George and Martha Washington, John Adams, and several other dignitaries made sure to visit the waterworks while in Bethlehem.

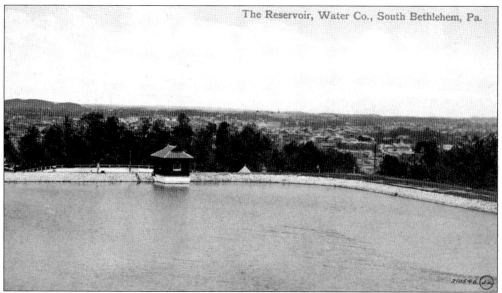

The Reservoir, Water Co., South Bethlehem, Pa.

Because the demand for water was high, Bethlehem South Gas and Water Company decided, in 1885, to build a new reservoir behind St. Luke's Hospital on Lehigh Mountain. The contractors, Brown and Goodnow, were unable to find local men to dig the reservoir. They paid local barber C. W. Welsh to travel to Hagerstown, Maryland, to find laborers; 23 black men were willing to travel to Fountain Hill for the work. The men arrived by train on July 15, 1885, and immediately built shanties to live in next to the reservoir. The work on the reservoir was completed in the spring of 1886.

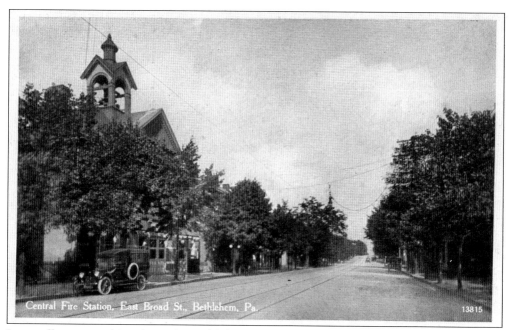

Central Fire Station, East Broad St., Bethlehem, Pa. 13815

In an effort to combine the various old fire departments around the city into a new, modern station, the Central Fire and Police Station was built by the city in 1893 at 57 East Broad Street. It was torn down in 1973 and replaced by a new fire station at 45 East Broad Street. The site of the fire station is a parking lot today.

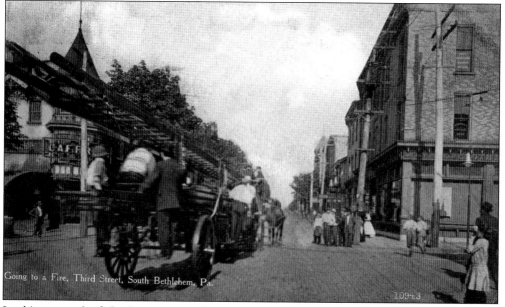

Going to a Fire, Third Street, South Bethlehem, Pa. 10943

In this postcard of the intersection of Third and New Streets, the Lehigh Hook and Ladder Company is traveling fast down Third Street to a fire. As the horse-drawn apparatus makes its way, two men can be seen running in the same direction, possibly to help the firemen at their destination. On November 5, 1895, South Bethlehem Council supplied this new, 75-foot horse-drawn Hayes aerial extension ladder truck to the company. Its ladder could extend as much as 85 feet in height.

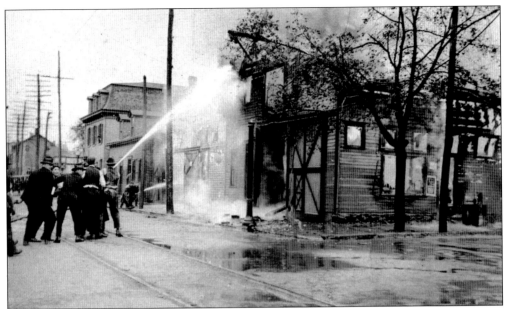

These men are fighting an intense fire as smoke is billowing out the windows and door of this wooden South Bethlehem garage. A fire like this would be of great concern to surrounding businesses and homeowners. The men controlling the fire hose are not dressed in waterproof attire, but appear determined to extinguish the fire. The telegraph poles and men's clothing indicate the photograph was taken in the 1920s.

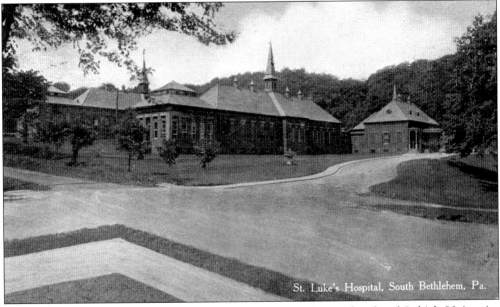

St. Luke's Hospital, South Bethlehem, Pa.

In 1875, Asa Packer, a judge and founder of the Lehigh Valley Railroad and Lehigh University, sold the so-called Water Cure property in Fountain Hill to Tinsley Jeeter for $25,000. The 20-acre property had two buildings and three barns. The St. Luke's Ladies Aid Society, a group organized by the wives of the captains of industry, raised the funds to purchase the property for a hospital. The first patients occupied the old Water Cure building on May 24, 1876. In 1877, the hospital took in 108 cases, and by 1878, it had 19 beds.

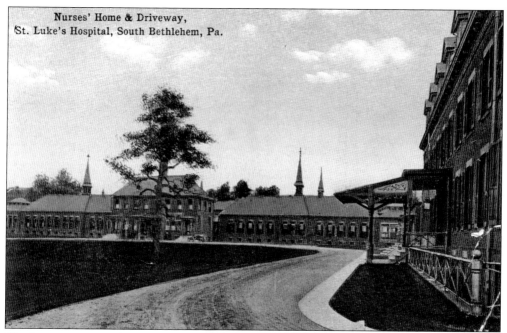

Nurses' Home & Driveway,
St. Luke's Hospital, South Bethlehem, Pa.

The front entrance to the Trexler Memorial Nurses Residence is pictured. It was completed in 1950 to accommodate at least 100 nurses. The building is still used today for student nurses' residences.

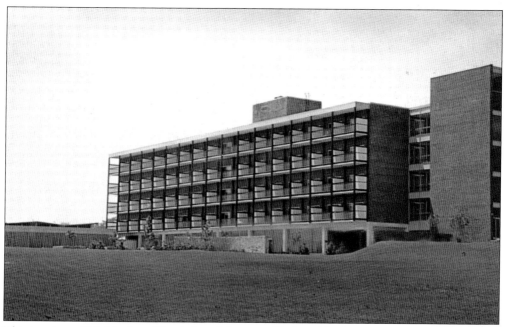

This is a view of Muhlenberg Hospital on Schoenersville Road, built in 1975. The hospital staff was proud of this modern, five-story, 50,000 square-foot building with 148 beds. Today, the hospital has more than doubled with an 80,000-square-foot south wing and the Kolb Center, a rehabilitation center and assisted living facility.

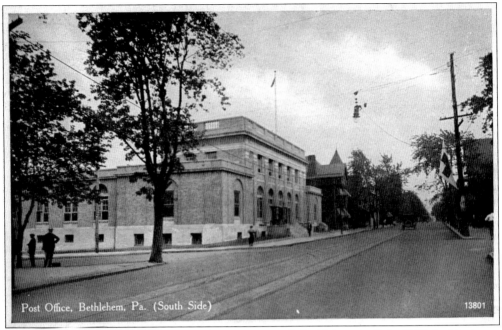

Post Office, Bethlehem, Pa. (South Side) 13801

This is a view of the post office on Fourth Street in South Bethlehem, built in 1917. At this time, a letter cost 3¢ to mail, and a postcard cost 2¢ to mail, reflecting rate increases from the war tax. The first postmaster of South Bethlehem was John Seem in 1866.

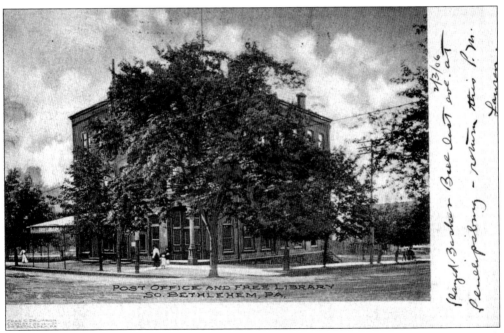

POST OFFICE AND FREE LIBRARY
SO. BETHLEHEM, PA.

South Bethlehem's post office and Free Library are pictured on West Fourth Street. The South Bethlehem Public Library was opened in 1906 at Fourth Street and Brodhead Avenue. This library moved four more times until a new building was erected in 1930 at its present location at Fourth and Webster Streets.

52

The Salvation Army began in the United States in 1879 through the efforts of Eliza Shirley, in Philadelphia. Members of her group arrived in Bethlehem in the summer of 1880 to distribute tracts about their organization. Their headquarters (pictured) was located at 615 Main Street. The famous Salvation Army Band is lined up in front. The band included members of the Salvation Army and only played religious music that had been specially arranged for them.

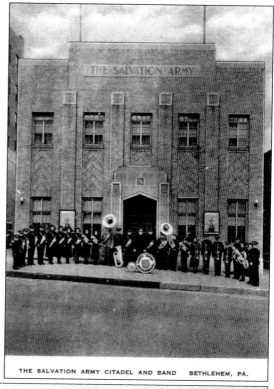

THE SALVATION ARMY CITADEL AND BAND BETHLEHEM, PA.

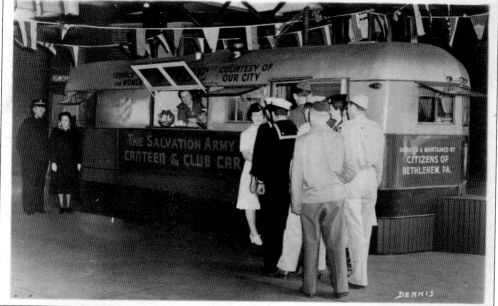

The Salvation Army Canteen and Club Car served the troops who rolled through the Bethlehem train station during World War II. Because of food rationing, food on trains was expensive. A soldier earning $21 a month often could not afford to eat. The United Service Organization (USO), of which the Salvation Army was a member, encouraged the creation of canteens to feed the troops. (Courtesy of Moravian Archives, Bethlehem, Pennsylvania.)

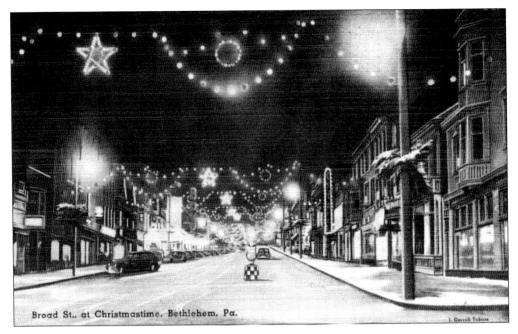

Broad St., at Christmastime, Bethlehem, Pa.

J. Carroll Tobias, the photographer of these two Christmas postcards, was an artist, tinkerer, and photographer who had an office in the basement of the Goundie House during the 1950s. The photograph above appears to have been taken in the 1930s when it became a community effort to publicize Bethlehem as "Christmas City, USA." Below, Tobias treats us to a night view of the beautiful Christmas decorations in Bethlehem. At the time he took this photograph, the Main Street ramp on the Hill-to-Hill Bridge was open to two-way traffic. It was changed to one-way in 1973. The picture must have been taken in the middle of the night, as thousands of tourists flocked to see the Christmas lights.

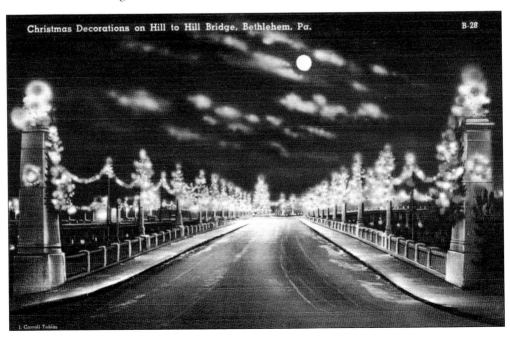

Christmas Decorations on Hill to Hill Bridge, Bethlehem, Pa. B-28

Five

BRIDGES

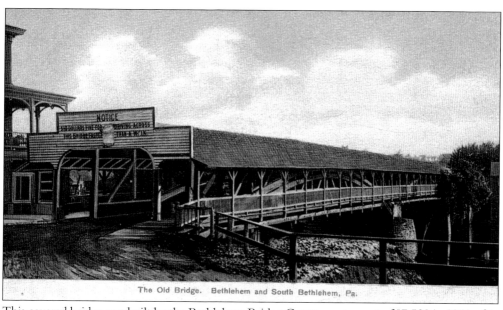

The Old Bridge. Bethlehem and South Bethlehem, Pa.

This covered bridge was built by the Bethlehem Bridge Company at a cost of $7,528 in 1841, after a flood of the Lehigh River destroyed the previous bridge. The washed-out bridge had been 23 feet above the low-water mark and 400 feet long. The Hill-to-Hill Bridge replaced it in 1924.

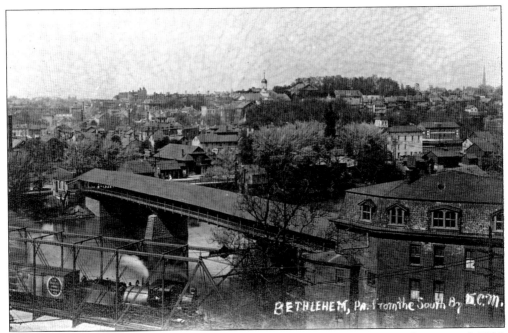

Here is a view of the Pacific Hotel, train trestle, and old covered bridge, taken around 1896. The hotel was built in 1871 and named Pacific House. An advertisement in 1879 stated that J.J. Marstellar was the proprietor, and the terms to stay at the hotel were moderate.

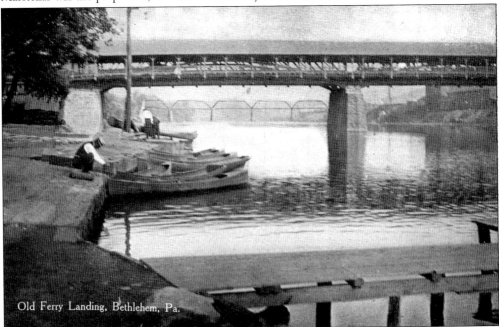

Old Ferry Landing, Bethlehem, Pa.

The Bethlehem Pike, opened in 1734, served as one of the earliest transportation routes between Bethlehem and Philadelphia. The pike terminated at the Crown Inn and ferry landing (now Wyandotte Street) in South Bethlehem. The ferry was abandoned upon the completion of a wooden bridge built at the site in 1794. The ferry operator, Massa Warner, was given the job of toll collector on the bridge.

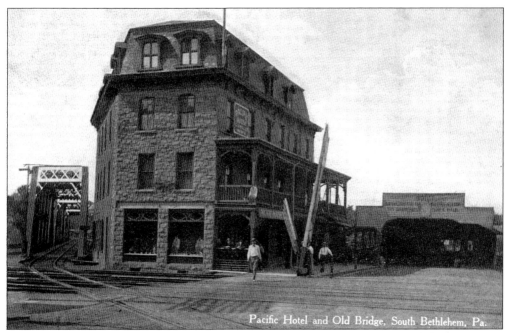

Pacific Hotel and Old Bridge, South Bethlehem, Pa.

Here is another view of the Pacific Hotel and old covered bridge in South Bethlehem. It was an extremely busy and dangerous intersection. The Pacific House was torn down in the early 1920s when the Hill-to-Hill Bridge was built to replace the covered bridge. The train trestle is to the left of the old bridge.

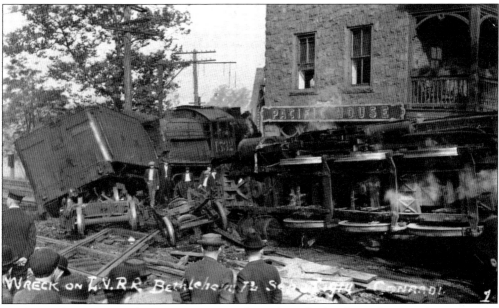

On September 27, 1914, there was a train wreck on the Lehigh Valley railroad tracks next to the Pacific Hotel. The convenient location of the hotel to the railroad passenger station did not seem worth it on days like this. C.F. Miller was the hotel proprietor. This hotel was a favorite spot for con artists who took advantage of the quick get-away available through trains run by the Lehigh Valley Railroad, the Reading Railroad, and the Central Railroad of New Jersey.

Rogers and Haggerty Inc., contractors from New York, began work on the Hill-to-Hill Bridge on August 1, 1921. It was completed on November 1, 1924, with Frank J. Flecksteiner as the first driver to cross it. Flecksteiner was a resident of Fountain Hill and employed as a chauffeur driver and machinist at Bethlehem Steel. At the height of construction, over 400 men were employed. The original bridge had eight approaches, 11 abutments, 48 piers, and 58 spans.

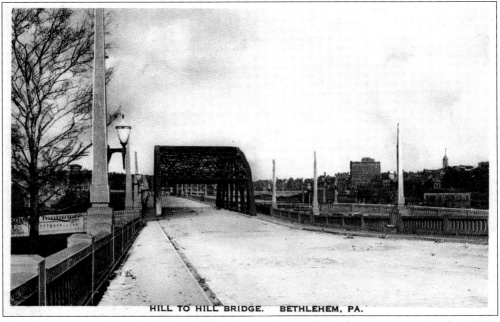

This view is approaching the Hill-to-Hill Bridge, going north. It takes a year to paint the 6,055-foot bridge. Painting is required every 10 years to ward off rust. The Pennsylvania Department of Transportation painted the bridge in 2009, at a cost of $1 million. As each section is sandblasted to prepare the surface to paint, a cover is wrapped around the area to catch old lead-based paint.

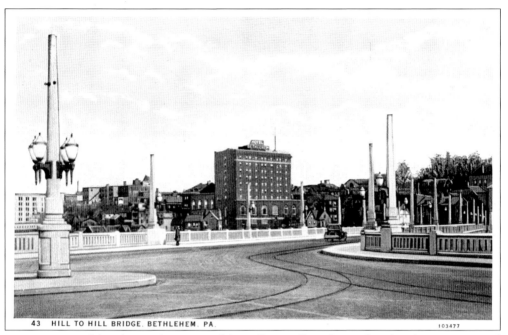

43 HILL TO HILL BRIDGE, BETHLEHEM, PA. 103477

Here is a view of the plaza in the center of the Hill-to-Hill Bridge. Before the plaza was removed in 1967, the city set up a huge Christmas tree there every holiday season. Two hundred native spruce trees were used to build the giant tree, which was then covered in lights.

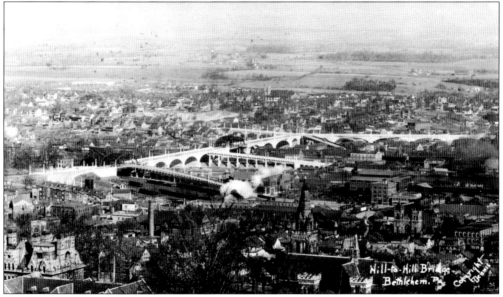

From this aerial view, the original ramps built for the Hill-to-Hill Bridge are clearly seen. Later structural changes included a new span in 1965 to carry Route 412 over East Fourth Street and the removal of the South Main Street ramp. In 1967, the plaza in the center of the Hill-to-Hill Bridge was removed when Route 378 connected the bridge to Route 22. In 1973, the west-side ramp was determined a traffic hazard and closed. Also at that time, the Main Street ramp was made one-way. The Second Street ramp was closed in 1985 and demolished in 1989. In 1988, the River Street ramp was demolished.

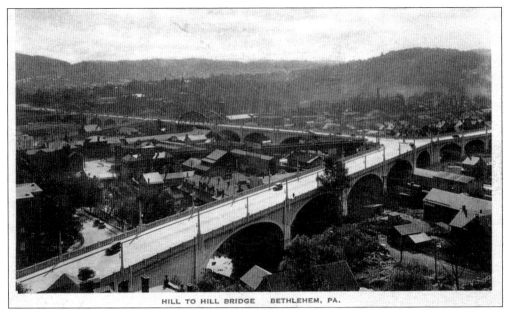

HILL TO HILL BRIDGE BETHLEHEM, PA.

This is an image of the Hill-to-Hill Bridge before the Route 378 spur was added in 1967. The residents of both Bethlehem and South Bethlehem were exasperated over the long delay in the building of this bridge. When it looked like all obstacles to building the bridge were finally surmounted, World War I broke out in 1917 and delayed the construction of the bridge until 1921. At the conclusion of the war, construction costs for the bridge had almost doubled.

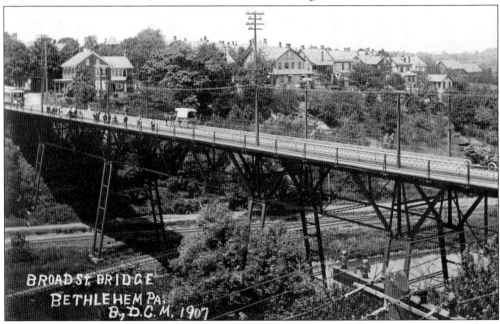

In this view of the Broad Street Bridge over the Monocacy Creek, three different forms of transportation appear. Railroad tracks run under the bridge, a horse-drawn cart passes by, and residents are walking across the bridge. By the date of this postcard in 1907, plans were already in place to build a new Broad Street Bridge, which was completed in 1910. (Courtesy of Moravian Archives, Bethlehem, Pennsylvania.)

60

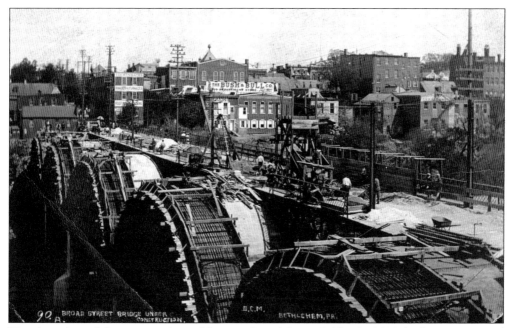

Here is a view of the construction of the new Broad Street Bridge in 1909, looking east toward Bethlehem. Also visible is the rear of the Bush & Bull Department Store. The bridge was a reinforced concrete structure.

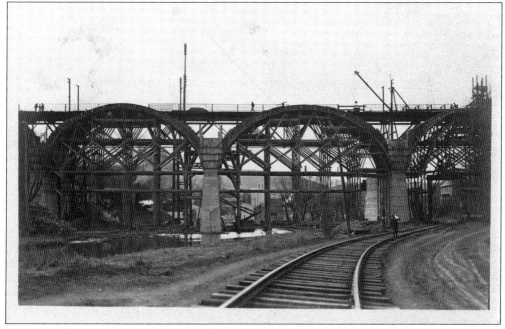

Here is another view of construction of the Broad Street Bridge in 1909. The bridge would rise high above the Lehigh & New England Railroad tracks. Johnston Park followed along the banks of the Monocacy Creek.

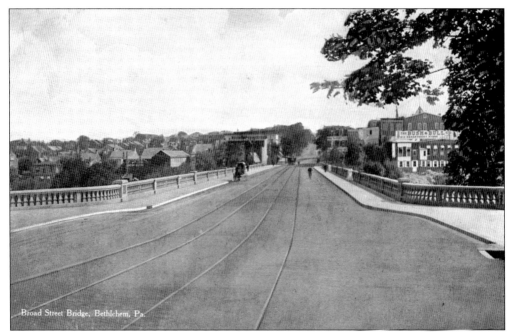

A horse-drawn cart crosses the Broad Street Bridge east toward Main Street in town. The concrete closed-spandrel arch bridge is 431 feet long and 41 feet wide. The bridge is still in heavy use, with 4,000 cars driving over it daily.

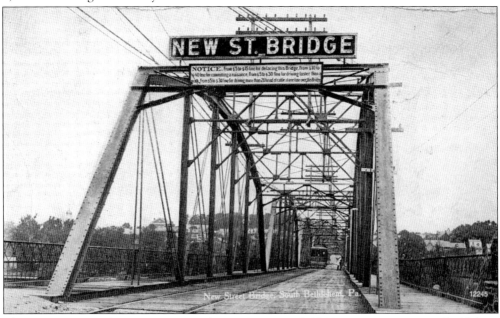

The New Street Bridge Company was chartered on May 3, 1864. Incorporators were Bethlehem leaders Aaron W. Radley, John T. Levers, Richard W. Leibert, and Herman Doster. The bridge spanned the tracks of the Lehigh & Susquehanna and Lehigh Valley Railroads, the Lehigh Canal, the Lehigh River, Monocacy Creek, and Sand Island, connecting the boroughs of Bethlehem and South Bethlehem at New Street. The structure, built of wrought iron and wood, rested upon eight piers. Its two end piers rested in Northampton County, while the central piers stood in Lehigh County.

Six

Main and Broad Streets

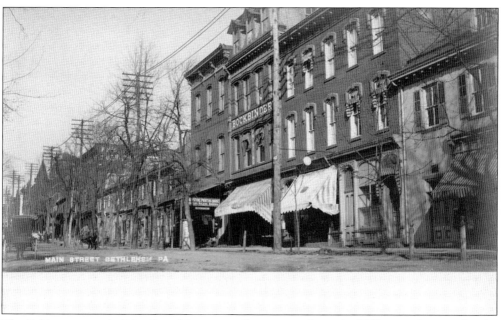

The "old economy building" or "the nursery" was torn down in 1870 to make way for the new Moravian Publication Office, seen with its sign, "Book Binder," prominently displayed. The Moravian Book Shop moved into the new building when it opened in 1871 and is in the same building today. The bookstore has been in existence since 1745.

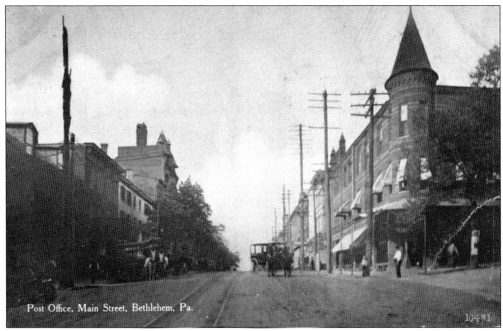

Post Office, Main Street, Bethlehem, Pa.

10481

This is a view of Main Street looking north from Market Street. The post office was located at 80 South Main Street on the northeast corner of Main and Market. From 1902 to 1925, the Bethlehem Public Library was located on the second floor.

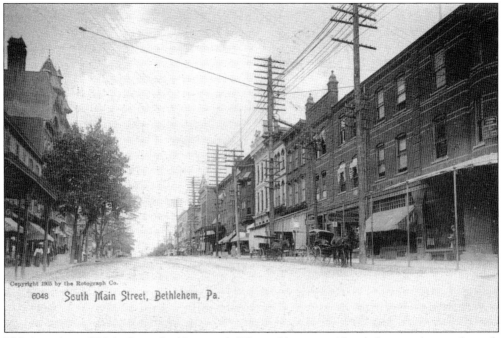

Copyright 1905 by the Rotograph Co.

6048 South Main Street, Bethlehem, Pa.

This is a view of Main Street looking north. The residents considered the prominent telegraph poles an eyesore, and the lines were buried underground by the 1920s. The Postal Telegraph Cable Company and Western Union Telegraph Company were within blocks of the businesses shown.

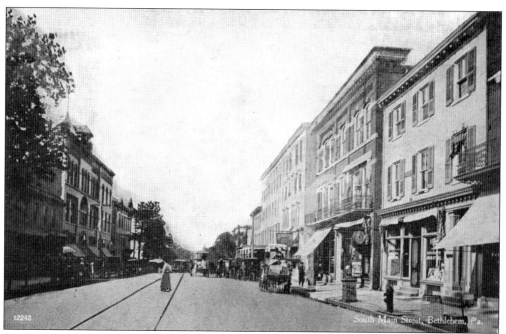

Here is an early-1900s view of Main Street showing horse-drawn carriages, trolley tracks, and a cobblestone street. People usually walked to their destinations, unless they could take a so-called electric car. Trolley tracks were first laid in Bethlehem in 1891. The trolleys struggled to climb the incline of Main Street going south.

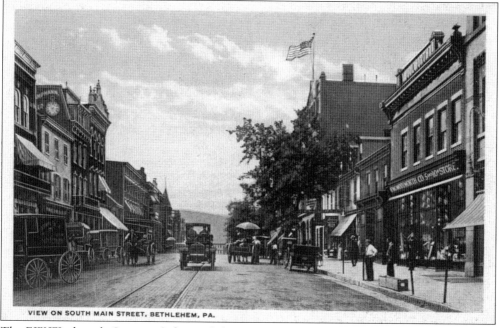

VIEW ON SOUTH MAIN STREET, BETHLEHEM, PA.

The F. W. Woolworth Company's five-and-dime store on the right closed in 1997. It was the first store to allow Bethlehem shoppers to handle and select merchandise without the assistance of a sales clerk.

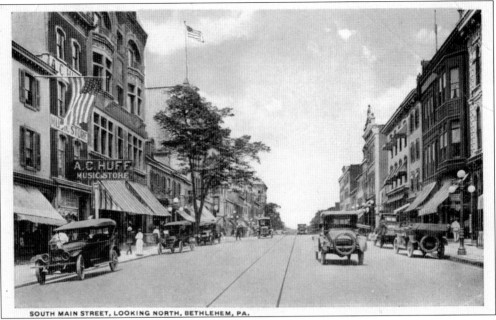

SOUTH MAIN STREET, LOOKING NORTH, BETHLEHEM, PA.

This view suggests that Theodore M. Freudenberger, a store awning installer located on Broad Street, was extremely busy. The store awnings on Main Street offered customers protection from sun, rain, and snow. However, just like the telegraph poles, they were eliminated in the 1920s to give the street a less cluttered look.

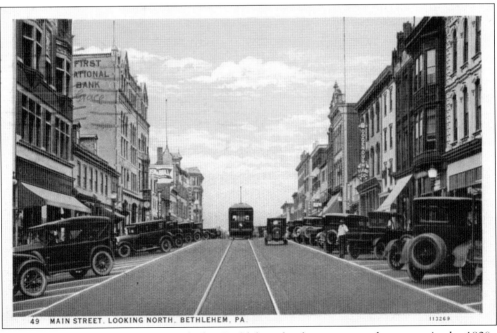

49 MAIN STREET, LOOKING NORTH, BETHLEHEM, PA. 113269

Looking south on Main Street reveals that Bethlehem has become a modern town in the 1920s. The horses and carriages are long gone, replaced by trolleys and Ford Model T, Chevrolet, and Oldsmobile cars. Most of these early cars were convertibles.

66

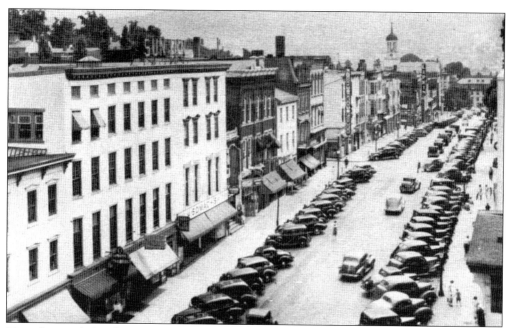

Nose-first, angled parking was instituted in the 1920s to allow more room for parking cars on busy Main Street. Charles Edward Goodenough started the Goodenough Piano Company on the right. Music lovers throughout the Lehigh Valley came to Goodenough's to buy their pianos.

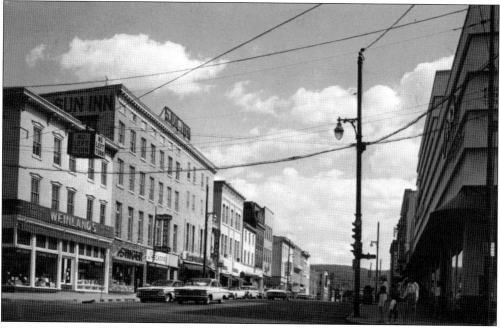

Main Street in the 1960s offered a wide variety of merchandise. Frederick E. Weinland's Hardware was located in a building erected in 1830. It burned in 2005, as it was under restoration. The Singer sewing machine store, Benjamin Sheckter's Shoes, and Somach's Woman's Apparel are in view.

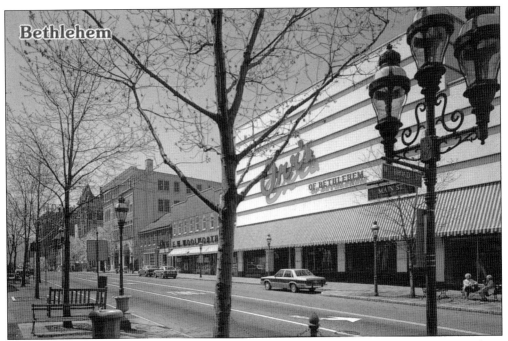

Here is a view of Main Street in the 1970s. Orr's Department Store was opened in 1957, taking the place of the Bush & Bull Department Store. The 50,000-square-foot store is actually three buildings, linked by a common facade. They were the original Bush & Bull, the Bee Hive, and the Luckenbach stove store. Orr's closed in 1993. Today, the building has been renovated into the Main Street Commons, an indoor mall.

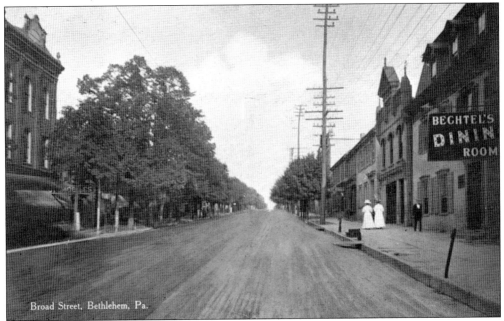

Many of the buildings in this view were demolished by the 1970s. On the right, Bechtel's Dining Rooms was owned by Harry B. Bechtel. On the left, Hoffman and Shimer offered bicycles for sale at the height of their popularity, switching to repairing automobiles after 1900.

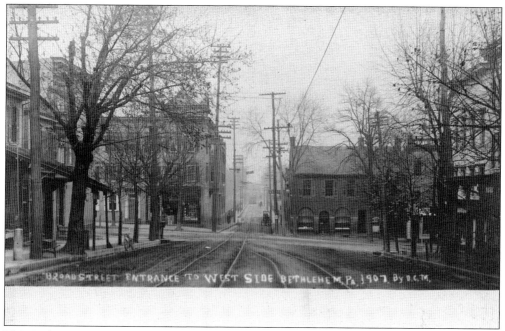

This is the intersection of Broad and Main Streets, looking toward West Bethlehem. Bush & Bull Department Store is on the southwest corner. The narrow lane leads to the Broad Street Bridge, a 460-foot iron bridge that spanned the Monocacy Creek, connecting Main Street with West Bethlehem.

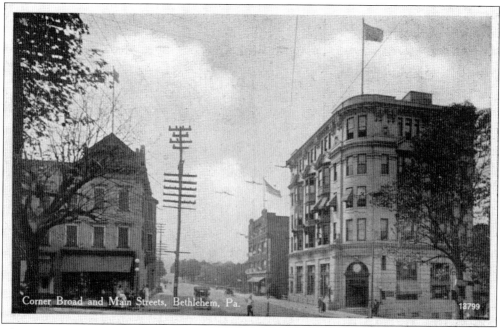

This is a view of the same intersection a decade later. A new concrete bridge replaced the iron one in 1909. The Bethlehem Trust Company dominates the northwest corner, with the Beck-Wilhelm Decorating Company next door.

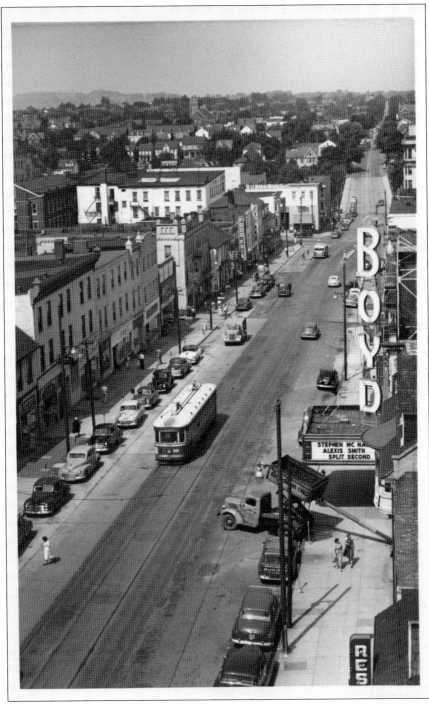

The Boyd Theater was originally called the Kurtz Theater and opened on September 1, 1921. A.R. Boyd Enterprises bought the theater in 1934 and changed its name to the Boyd. This view shows the theater before the 1966 fire that started in a nearby retail shop and caused damage to the theater's lobby, external facade, and marquee. The marquee displays the title of the 1953 film *Split Second*, starring Stephen McNally and Alexis Smith.

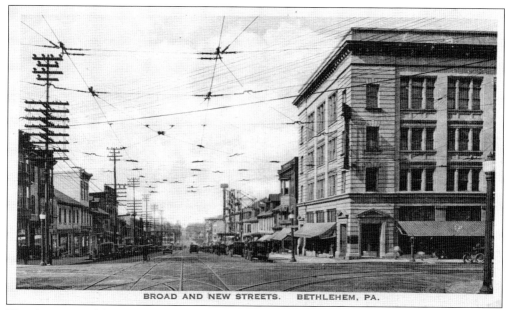

BROAD AND NEW STREETS. BETHLEHEM, PA.

Here is a view of the busy intersection of Broad and New Streets looking west on Broad Street. The tracks belong to the Lehigh Valley Transit Company, which provided trolley service from 1899 to 1953. Double tracks travel down both New and Broad Streets. On the left is the Dennis Drug Store. On the right is the Farr's building, a Beaux Arts design that was originally an Independent Order of Odd Fellows (IOOF) lodge, built 150 years ago. The Boyd Theater can be seen further down the block on the right.

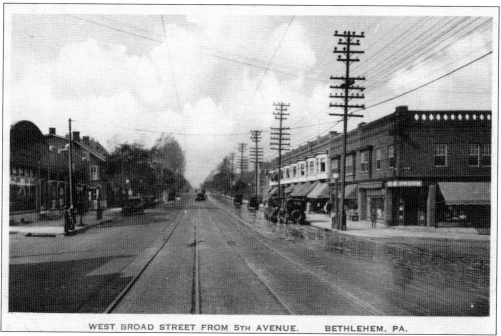

WEST BROAD STREET FROM 5TH AVENUE. BETHLEHEM, PA.

Residents could catch a trolley on Broad Street and ride west to Allentown, but they could usually find everything they needed in the stores along Broad Street. At this intersection of West Broad Street and 5th Avenue, there is Fasnacht's Pharmacy and Bethlehem Tire and Battery Company.

71

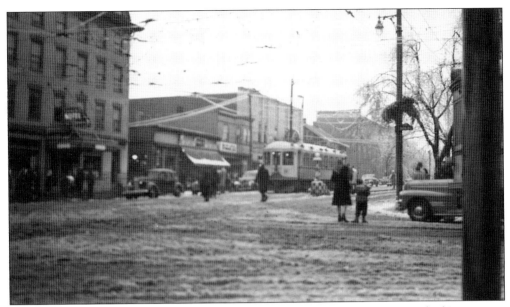

It is a snowy day in January 1948 at the intersection of Broad and New Streets, looking east on Broad Street. The American Hotel is on the far left. The Lehigh Barber Shop, Tocci Brothers News Stand, and Dorolee Ladies Shop appear along the north side of the block. A bus would replace the trolley shown riding down Broad Street within a few years. The American Hotel opened a bus terminal in its lobby in the early 1950s.

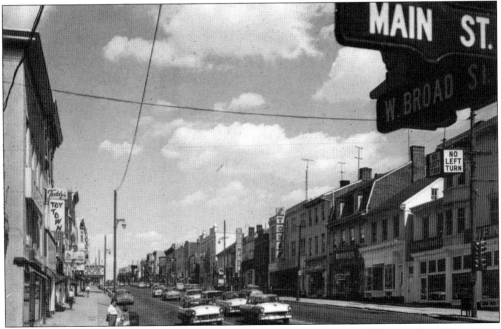

This view shows a block of busy downtown businesses on West Broad Street, taken from Main Street. On the north side of the street are Teddy's Toy Town and the Nile Theater. On the south side are Food Fair, Stone's Women's Furnishings, and Warner's Drug Store.

Seven

OTHER STREET VIEWS

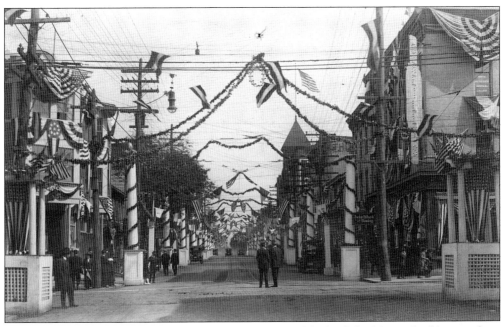

Third Street has never looked so festive. Pictured is the 400 block of Third Street, looking east from New Street. O'Reilly's Furniture is immediately on the right, but hidden under all the patriotic decorations. The Market House can be seen further down the block. This looks like an important celebration, possibly the kickoff for a Liberty Loan campaign in 1917 or 1918. (Courtesy of the Bethlehem Area Public Library.)

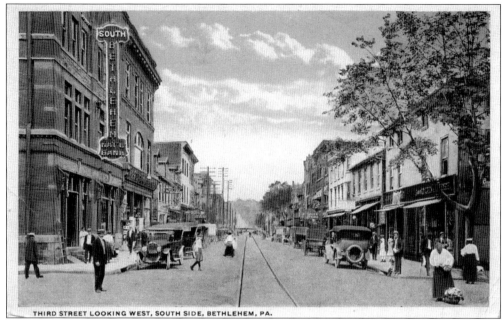

THIRD STREET LOOKING WEST, SOUTH SIDE, BETHLEHEM, PA.

People came from all over the Lehigh Valley to shop on Third Street, the principal business center in South Bethlehem. This is the intersection of Third and Adams Streets. The South Bethlehem National Bank is on the left, and C.P. Hoffman & Company General Store is on the right. The straw hats on the men and long dresses on the women indicate the photograph was taken in the early 1900s.

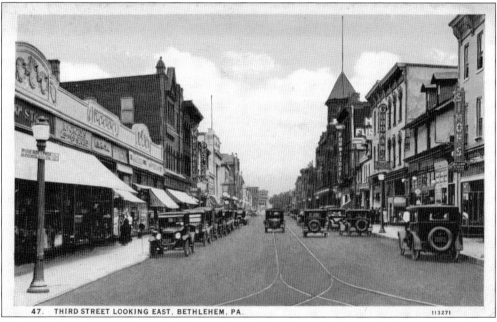

47. THIRD STREET LOOKING EAST, BETHLEHEM, PA. 113271

Here is a view of Third Street, looking east from New Street. A sign on the lamp post points to Philadelphia and Points South, as the intersection of old Route 12 was straight ahead. On the left are McCrory's five-and-dime store and M.E. Kreidler Boots and Shoes. On the right is Simons Ready To Wear clothing store and Goodman's Furniture Store. Farther down the block is the Market House.

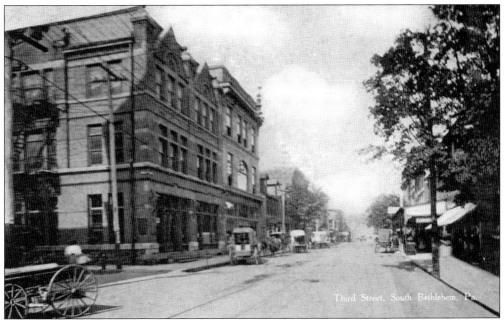

Only horse-driven carriages can be seen in this view of Third Street at the intersection of Adams Street, indicating this as a postcard from the very early 1900s. On the left is F. W. Martenis Grocer and Dry Goods. Frank and Lewis Martenis started the grocery business together. Frank continued with it after his brother Lewis passed away in 1898. Out of view on the right is the Market House.

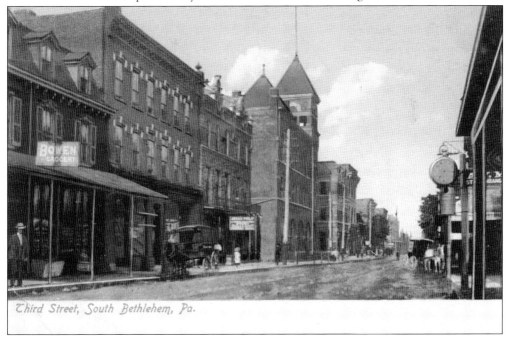

This is another early-1900s postcard of the businesses on Third Street. Bowen Grocery, at 120 East Third Street, is in the foreground. Farther down the block are Abraham Phillips Dry Goods Store and the impressive Market House. On the right is a large clock, of great assistance to people who were unable to afford a timepiece.

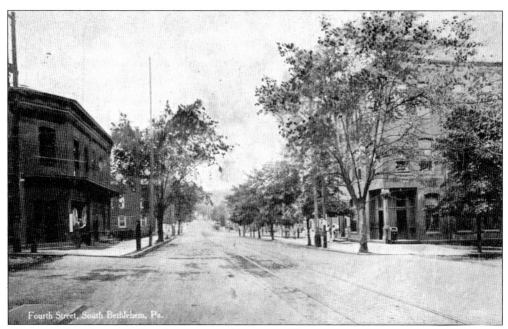

The post office for South Bethlehem is on the right, at 201 West Fourth Street. Across the street is the F.J. Miller and W.H. Markle Sporting Goods Store that sold bicycles, Spaulding baseballs, and other goods such as gloves, mitts, and tennis racquets. Lehigh University students were their biggest customers. This is the intersection of Brodhead and Fourth Streets.

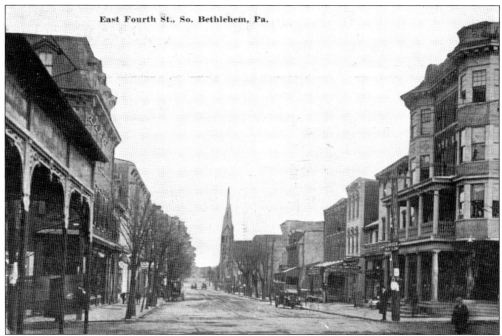

This is the intersection of New and Fourth Streets, looking east. On the right is the New Merchants Hotel, located at 2 East Fourth Street. On the left is Cyrus Jacoby's Drugstore. Further down the block is a sign for J.L. Bolich Undertaker, and in the distance is the tall steeple of Holy Infancy Church.

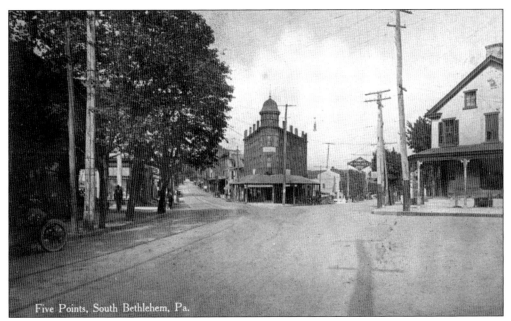

Five Points, South Bethlehem, Pa.

This is a view of Five Points where Wyandotte and Fourth Streets intersected. Straight ahead in the middle of the postcard is the Wyandotte Hotel and Fountain Hill Opera House. On the right is the Sanford Cafe and Hotel, owned by Garrett B. Lindeman. In 1888, Lindeman advertised his restaurant, cafe, and salons as "unexcelled." The rooms were $2 per day.

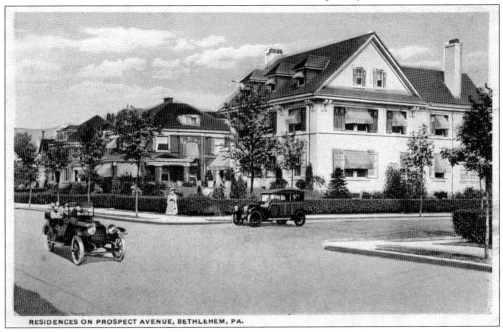

RESIDENCES ON PROSPECT AVENUE, BETHLEHEM, PA.

The Old Allentown Road was renamed Prospect Avenue as West Bethlehem was becoming more developed in the early 1900s. The automobile allowed Bethlehem Steel executives to build their mansions in the Mount Airy District along Prospect Avenue. The famous Bethlehem Steel Bonus Plan helped build these large modern homes. A typical home in this neighborhood had six bedrooms, oil heat, large yards, a two-car garage, three bathrooms, and a laundry room.

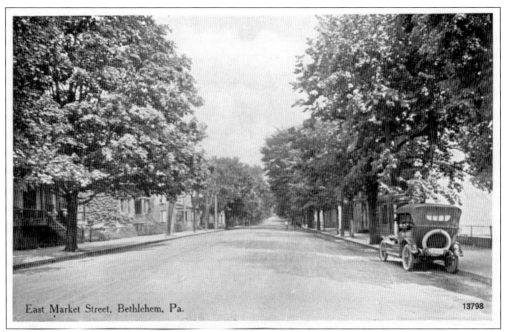

East Market Street, Bethlehem, Pa.

13798

This view of East Market Street shows a nice residential neighborhood. For generations, the old Moravian families bought lots along Market Street for their homes. At the time this photograph was taken in the early 1900s, the Luckenbachs, Dodsons, Weavers, and Myers families could be found living side-by-side along the quiet, shady street.

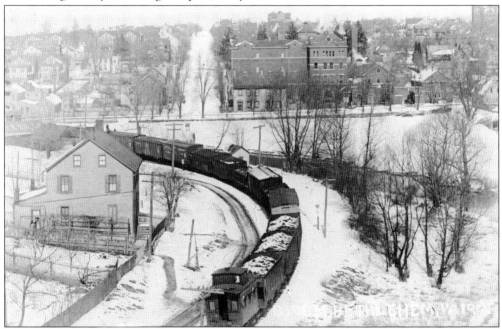

Here is a view looking north to the Monacacy Creek and Union Boulevard, each running east to west. Straight ahead, the road seen in the distance is Monacacy Street. M. Uhl's Brewery on the right corner is the Old Brewery Tavern today. The building closest to the train is a structure of the Pure Oil Company.

Eight

Transportation

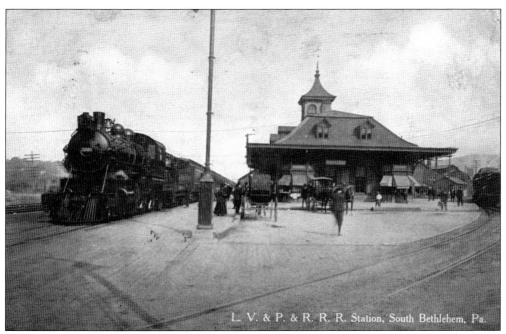

L. V. & P. & R. R. R. Station, South Bethlehem, Pa.

The Bethlehem Union Depot opened on November 18, 1867, to serve the passengers of the Lehigh Valley and North Pennsylvania Railroads. The businessmen of Bethlehem and employees of the two railroads lined the platform to welcome the first Lehigh Valley westbound train to arrive at the depot. The steam-powered locomotive traveled northwest to Mauch Chunk (Jim Thorpe). The depot was demolished in 1924 and replaced by a Classical Greek brick structure.

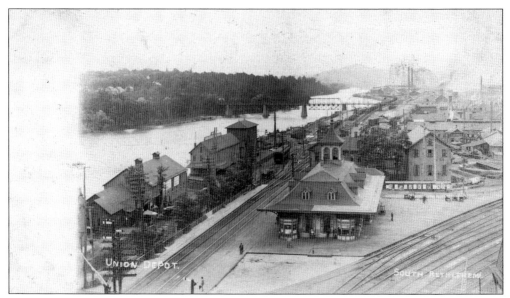

Asa Packer, a wealthy canal boatyard operator, construction contractor, and coal mine owner, saw the railroad as an improvement over the canal system. In 1852, he bought up the majority of the stock in the Delaware, Lehigh, Schuylkill & Susquehanna Railroad and provided the leadership to make it a successful operation. Packer began blasting limestone bluffs between Bethlehem and Easton. By the time the railroad was known as Lehigh Valley Railroad, it offered access to Philadelphia and New York.

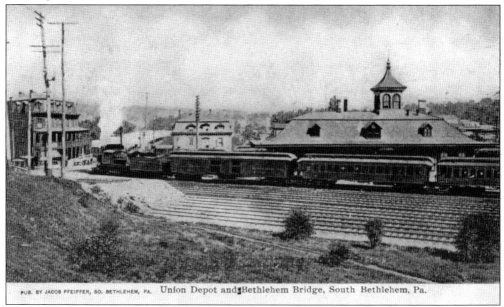

PUB. BY JACOB PFEIFFER, SO. BETHLEHEM, PA. Union Depot and Bethlehem Bridge, South Bethlehem, Pa.

In this view, the Pacific Hotel is on the left and Union Depot on the right. The Philadelphia & Reading Railway, the Lehigh Valley Railroad, and the Central Railroad of New Jersey all used the tracks in front of the depot, creating three dangerous railroad crossings in the area. The Public Service Commission ordered the abolishment of the crossings because of the countless number of deaths and injuries to humans and horses. The building of the Hill-to-Hill Bridge alleviated the problem of crossing the tracks.

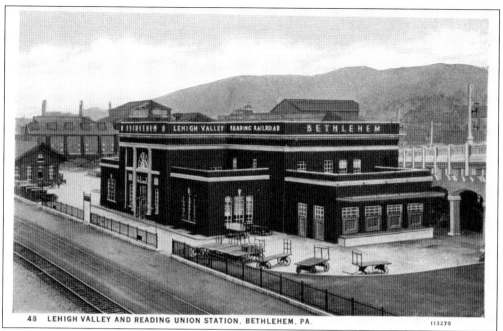

48 LEHIGH VALLEY AND READING UNION STATION, BETHLEHEM, PA. 113270

Here is a view of the Union Depot, which still exists today. The Lehigh Valley Railroad ceased operations in 1961. The Reading Railroad ended its passenger pickup outside of the Union Depot in 1978. The last Lehigh Valley Railroad train to leave the depot was the Maple Leaf, bound for New York. On its final run on February 4, 1961, it was hammered by a blizzard that piled 17 inches of snow on the tracks. The old train, unable to complete the route to New York, came to a final rest at Newark's Penn Station.

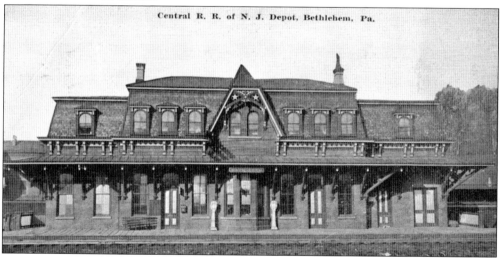

Central R. R. of N. J. Depot, Bethlehem, Pa.

Here is the beautiful, brick, Victorian-style Central Railroad of New Jersey Depot, located on Lehigh Street near Sand Island. It was built in 1873. Teddy Roosevelt came on a whistle-stop campaign in 1908 and addressed the crowd from the rear of his car, named the "Roosevelt Special." Pres. Harry S. Truman made a whistle-stop campaign visit on October 7, 1948. The Central Railroad of New Jersey went bankrupt in 1976 and was taken over by Conrail. The depot was restored, and a restaurant has operated there over the years. The building was placed in the National Register of Historic Places.

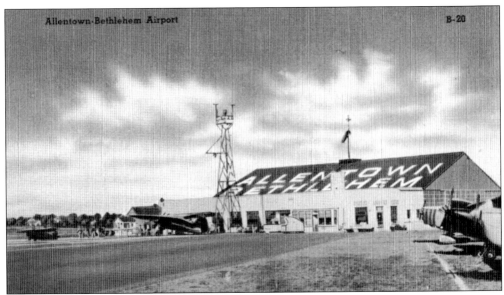

The Lehigh Valley International Airport began in 1927 when the US Department of Commerce rented 50 acres of farmland as an emergency-landing airstrip for airmail pilots. A steel tower topped by a rotating beacon was erected, and a small frame building was constructed for an attendant. This wooden structure eventually became the first terminal for the Allentown Airport Corporation. It is one of the oldest airports in the country still operating from its original location. The property was perfectly located in Hanover Township, between Lehigh and Northampton Counties.

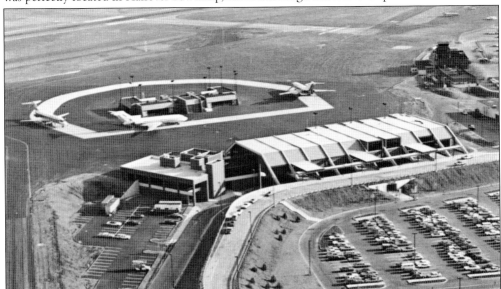

In October 1975, local newspapers announced plans for dedication ceremonies to celebrate the opening of the new terminal at Lehigh Valley International Airport. Over 1,000 people attended the largest dinner dance held in the Lehigh Valley. Some 13,000 people previewed the multi-million-dollar terminal complex that would begin operations on December 14. The main terminal was encased in 11 steel frames, each 172 feet long and spaced 30 feet apart. The main terminal was built into the terrain to give it a lower profile. In addition, the new departure lounge, food service wing, and 1,000-car parking lot made flying much easier for travelers.

Nine

OTHER BUSINESSES

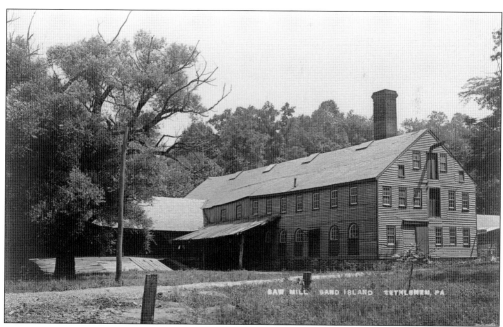

A sawmill was erected on Sand Island within a few years of the settlement of Moravians in Bethlehem. During the Revolutionary War, when Bethlehem was the location of a hospital, the Continental Army set up barracks on Sand Island next to the sawmill. The sawmill in this view was purchased by Lewis Doster in 1843 and used to house his wool manufacturing business.

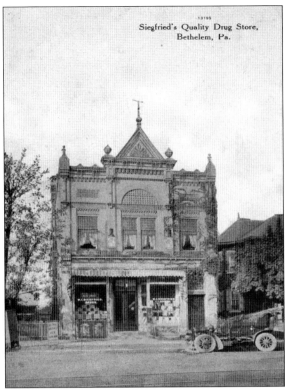

Siegfried's Quality Drug Store,
Bethelem, Pa.

William J. Siegfried's Drugstore was designed by architect A. W. Leh and built in the late 1880s. This photograph of 213 W. Broad Street was taken in 1910. The location served as a drugstore for almost 100 years for various pharmacists. Today, it is home to Ambre Studio, an art gallery.

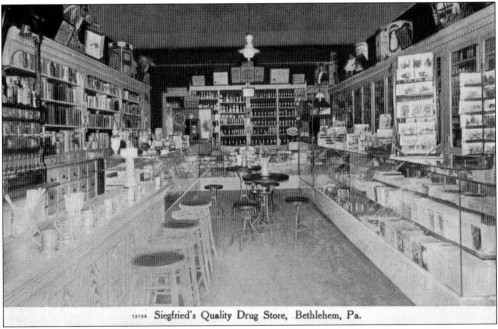

Siegfried's Quality Drug Store, Bethlehem, Pa.

Here is a look inside Siegfried's Drugstore. The stools are lined up at the soda fountain. Siegfried's was the first business in town to install a refrigerator. Postcards are for sale on the counter on the right. Siegfried sent out this postcard in December 1909 to remind employers that cigars, which he had in stock, were great presents.

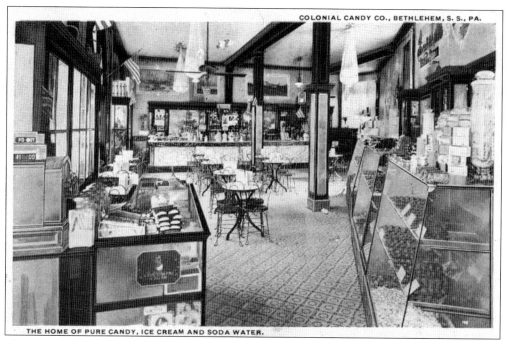

COLONIAL CANDY CO., BETHLEHEM, S. S., PA.

THE HOME OF PURE CANDY, ICE CREAM AND SODA WATER.

The Baganakis Brothers opened the Colonial Candy Company in South Bethlehem. It featured homemade candy and ice cream made of the purest ingredients. The case on the left has a Robert Burns' Cigars logo pasted on the glass. On a hot summer day, the ceiling fan and a large bowl of ice cream would be very welcome.

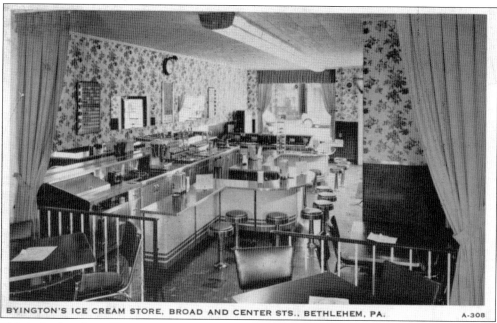

BYINGTON'S ICE CREAM STORE, BROAD AND CENTER STS., BETHLEHEM, PA. A-308

This is the interior of Byington's Ice Cream Store at the corner of Broad and Center Streets. E.B. Byington was the general ticket agent for the Lehigh Valley Railroad. Although he was posted in Mauch Chunk and Buffalo, he decided that Bethlehem was the best location for an ice cream parlor. In this view, the counters are gleaming, and each table has a menu of the ice cream flavors of the day.

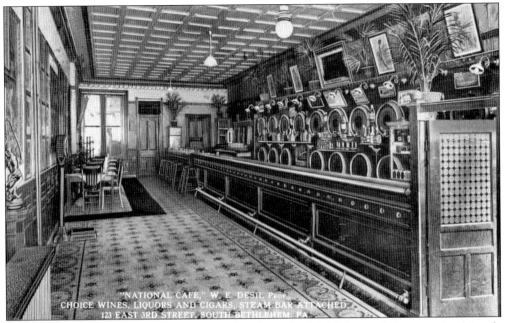

This is the interior of the bar at the National Cafe on East Third Street. Before opening his cafe, Warren E. Desh was the manager of Reliable Steam Laundry, located behind the American Hotel. Warren was the son of George D. Desh, a prominent man in Bethlehem and owner of a butcher store in town.

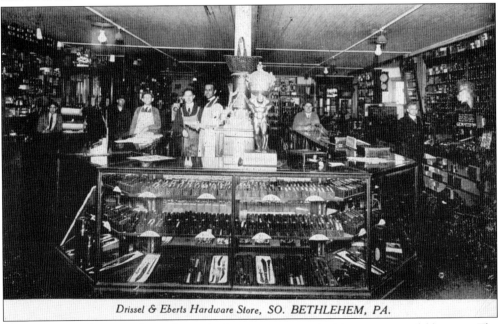

Drissel & Eberts Hardware Store, SO. BETHLEHEM, PA.

At Drissel and Eberts Hardware Store, the inventory was packed into every available space. The store was located at 21–23 East Third Street. Co-owner Elmer F. Eberts was also the bookkeeper for the South Bethlehem National Bank and president of the People's Trust Company. Elmer married Anna, the daughter of his business partner John Drissel, in 1892. Although John Drissel died in 1910, Eberts carried on the business in both of their names.

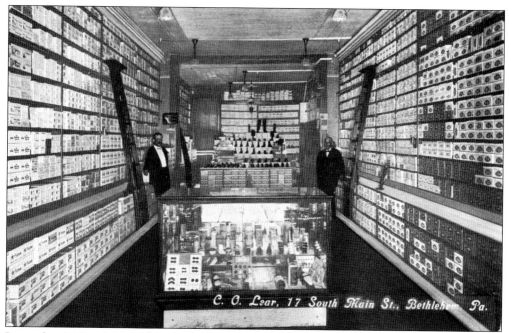

Located at 17 South Main Street, Clinton Overpeck Lear was a dealer in fine footwear for men, women, and children. Lear also offered a shoe repair service. He sold the W.L. Douglas shoe that was advertised with the slogan, "When a well-groomed look counts most."

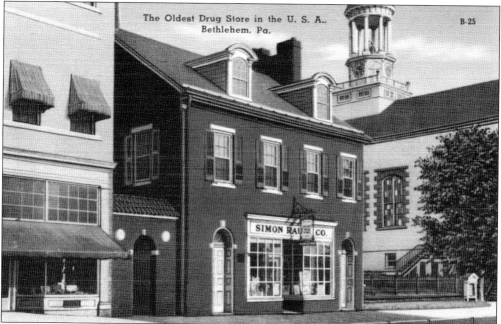

This view of the Simon Rau Drugstore is on Main Street next to the Moravian Central Church. The Rau family settled in the Bethlehem area in 1768. Dr. Matthew Otto founded the pharmacy in 1743 at this location. Otto died in 1790 and was succeeded by Dr. Everett Freytag. Simon Rau was an apprentice to Freytag in 1830 and succeeded him upon his death in 1846. The Rau family carried on the business until 1951.

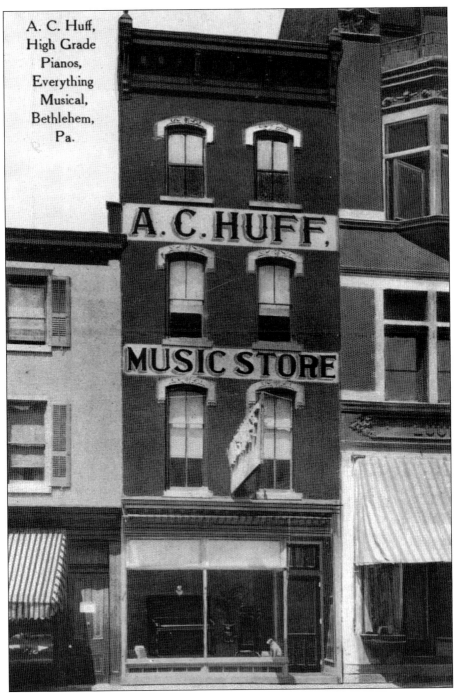

A. C. Huff,
High Grade
Pianos,
Everything
Musical,
Bethlehem,
Pa.

Almer Charles Huff, who previously sold sewing machines and other sundries, opened A.C. Huff Music Store on Main Street in 1894. The Huff Music Store sold Steinway, Behr, Chickering, Emerson, and Player pianos. It was the place in town to buy phonograph machines and records. Other musical instruments for sale were violins, banjos, guitars, and mandolins. Huff was an important man in town. He served on Bethlehem council in the years 1904–1913 and on several committees, such as the consolidation of the Bethlehems in 1817.

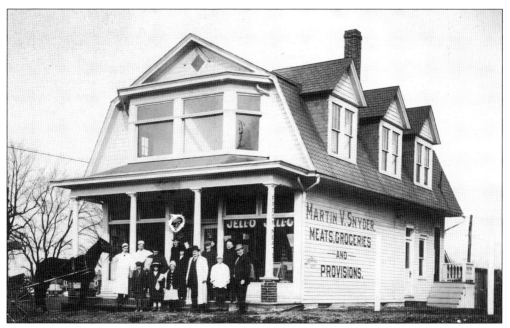

Martin V. Snyder's grocery store was a popular place to catch up on the news of the community. It was located in West Bethlehem. Snyder, his wife, Ella Long, and daughter Minnie lived on the second floor. Snyder was born in Lynn Township and began his career as a farmer and carpenter.

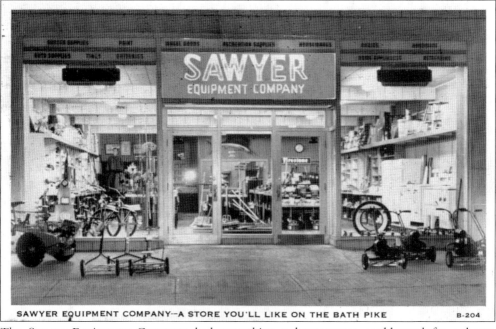

The Sawyer Equipment Company had everything a homeowner could need for a home improvement project. The store, located at 1330 Center Street (otherwise known as Bath Pike), announced its new location with this postcard. Previously, the business was located at 1446 Linden Street.

These Western Union Telegraph Company delivery boys are ready to deliver that next important telegram. They present a nice appearance in their button-down shirts and ties. Western Union was located at 512 Main Street. The company was open every day, and could send cables, letters, and telegraphs.

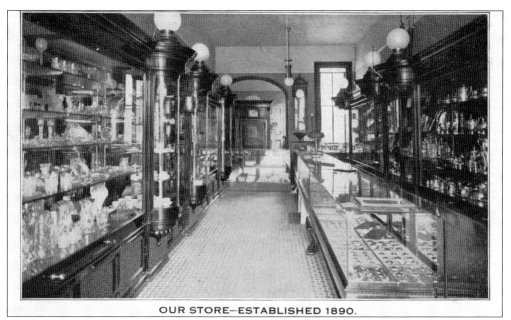

OUR STORE—ESTABLISHED 1890.

Here is a view inside H.H. Greiner Jewelry Store, located at 150 South Main Street. Greiner's offered a variety of items with the Lehigh University seal, such as pins, charms, and rings. They repaired watches and eyeglasses. The store was established in 1890.

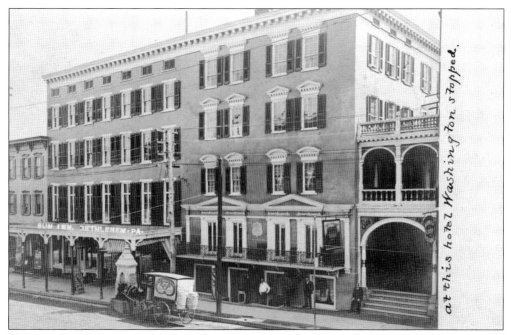

This is a view of the Sun Inn, built by the Moravian congregation in 1758. In 1826, a full story was added to the building, as seen in this photograph. The Erwin J. Bruch Pretzel wagon is stopped in front of the hotel. Bruch's pretzels were much in demand, as they were his specialty.

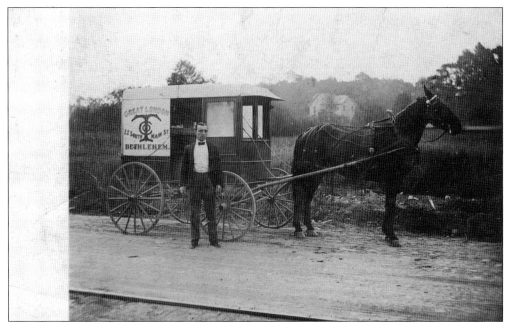

The Great London Tea Company was located at 22 South Main Street. T.R. Parker was the manager. Also seen is a store delivery cart, which was essential to doing a good business in Bethlehem. The store offered teas, coffees, spices, and Wedgwood Queens Ware. Tea was popular in Bethlehem, and the residents supported many tearooms over the years.

The Simon King Moving Company delivery wagon appears empty, but the use of four horses indicates there was a heavy load. The dog sitting on the horse looks quite comfortable. With those wooden wheels on the wagon, the dog would have felt every bump in the road.

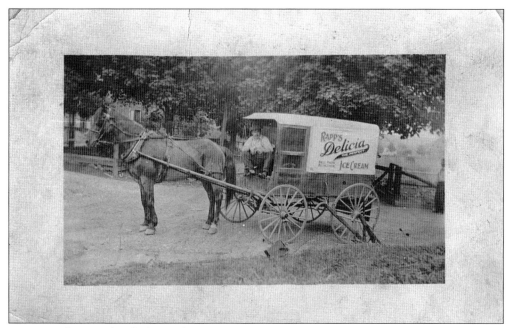

Here is a photograph of a horse-drawn cart delivering "Rapp's Delicia, The Perfect Ice Cream." The advertising mentions "Bell Phone, Bethlehem," suggesting a way to order a delivery. Chocolate was the favorite flavor of ice cream in the early 1900s. There were several dairy farms in the Lehigh Valley to provide fresh milk.

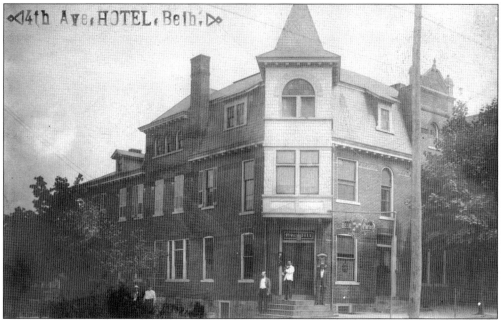

Here is a view of the Fourteenth Avenue Hotel, at 345 West Broad Street, in West Bethlehem. There was a barroom on the first floor, indicated by the Horlacher's beer and porter sign. The Horlacher Brewing Company, based in Allentown, closed in 1978. The gentlemen standing in front of the hotel are well dressed. The man in the white coat is holding a pet monkey, possibly the mascot of the hotel.

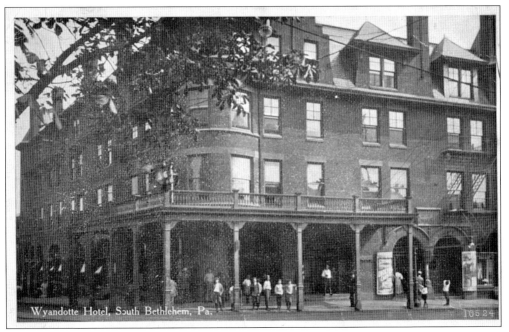

Here is the popular Wyandotte Hotel, located on the corner of Wyandotte and Broad Streets, at Five Points. It is a busy location with families, a group of young boys, and several men walking by. When E.P. Wilbur's Opera House burned in 1884, he erected the Wyandotte Hotel and a theater on the site.

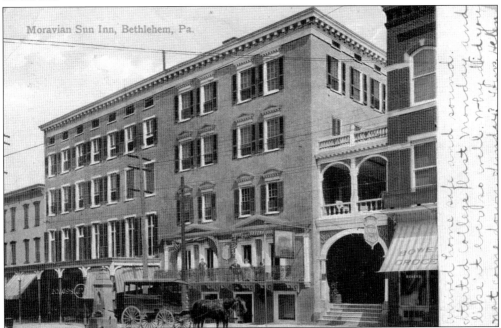

In this view of the Sun Inn on Main Street, the entrance to the stable is visible on the right. Bowen's Grocery Company is on the far right. Several storefronts line the sidewalk under the hotel, including a barbershop and cigar shop. A cart drawn by two horses has stopped in front of the hotel.

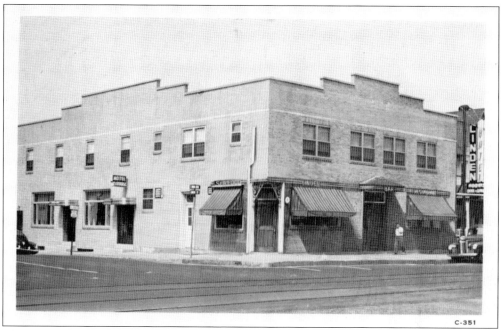

C-351

The Linden Hotel, located on East Union Boulevard, had separate entrances for the bar, restaurant, and hotel. Its advertisement promised "Friendly and efficient service." Seafood was a specialty of the restaurant. Pantelis and Ipatia Mihalakis owned the hotel from 1940 to 1960.

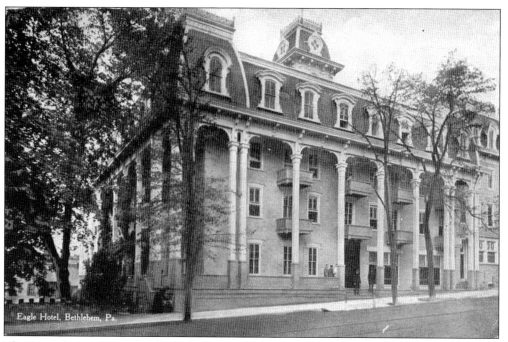

Eagle Hotel, Bethlehem, Pa.

The Moravian congregation built the Golden Eagle Hotel, later renamed the Eagle Hotel, in 1794. The first house in Bethlehem, built in 1741, was removed in 1823 to make way for the hotel stables. Many local government elections and meetings took place there. The Eagle Hotel was torn down in 1919 to be replaced by the Hotel Bethlehem on the same site.

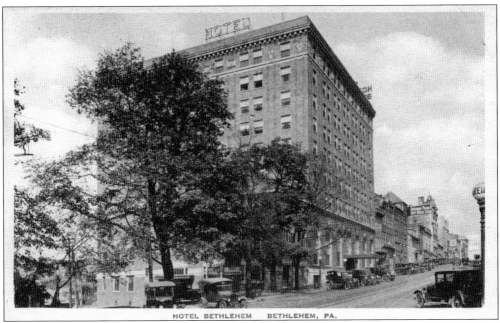

HOTEL BETHLEHEM BETHLEHEM, PA.

The Hotel Bethlehem was built in 1922 on Main Street. At the time, it was the most modern and luxurious hotel in the Lehigh Valley. Philadelphia architects Ritter and Shay designed the hotel. Charles M. Schwab initiated the building of this hotel to cater to Bethlehem Steel's wealthy customers. The hotel installed a barbershop, shoe-shine stand, and coffee shop in the lower lobby.

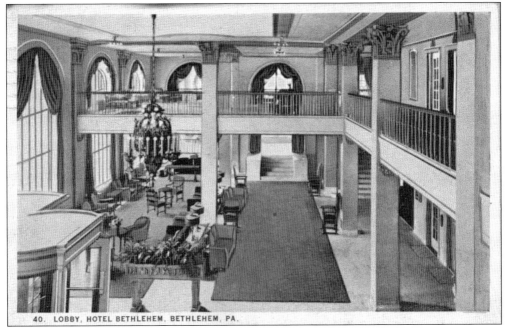

40. LOBBY, HOTEL BETHLEHEM, BETHLEHEM, PA.

The seven-story structure of the Hotel Bethlehem was built for $800,000. The lobby was finished in cream and gold with dark blue accessories. Palms and ferns were placed artistically throughout the room. A basket with a large bouquet of pink rosebuds overshadowed the hotel desk. The lobby was furnished with overstuffed couches and chairs covered in warm red velvet material.

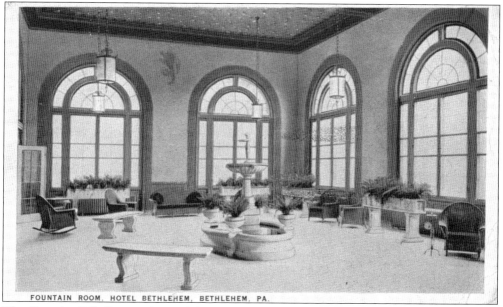

FOUNTAIN ROOM, HOTEL BETHLEHEM, BETHLEHEM, PA.

The Georgian Palladian windows of the Fountain Room overlooked historic Main Street. Today, the restaurant 1741 on the Terrace is located in the room. The Moravian Pottery and Tile Works in Bucks County created the tile floor in 1925. The tiles were covered by a gold rug from a previous renovation for years. Luckily, they were rediscovered during a recent remodeling. In the 1950s, the old fountain was removed and tiles representing the Star of Bethlehem covered the area.

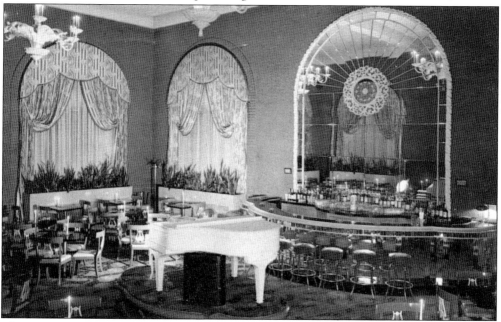

The Candlelight Room was also located in the terrace room and was selected as the ideal room to celebrate Bethlehem mayoral inaugural balls, graduations, weddings, and fundraisers. Today, the Tap Room has photographs lining the walls of the famous people who have stayed at or visited the hotel. Muhammad Ali, Richard Nixon, the Dalai Lama, John F. Kennedy, and Barrack Obama have visited the hotel.

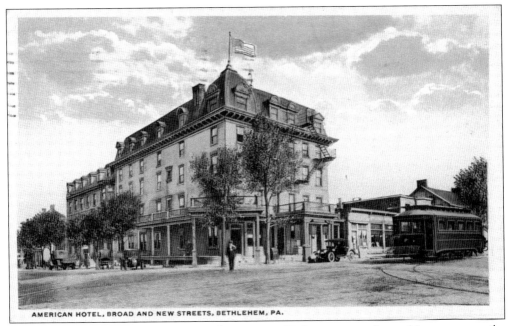

AMERICAN HOTEL, BROAD AND NEW STREETS, BETHLEHEM, PA.

The American Hotel is seen on the northeast corner. Various owners changed its name over the years. In 1861, it was known as the Bethlehem House and later as the American House. The hotel was known for its good food and views. Guests would climb to the roof to observe sunsets and a view of the Blue Mountains to the north.

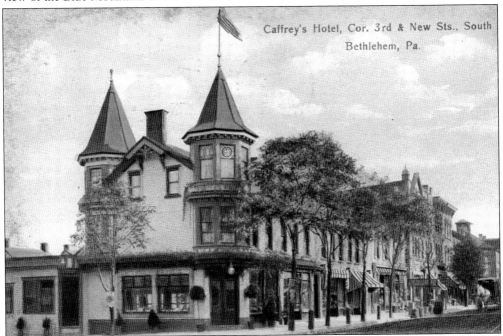

Caffrey's Hotel, Cor. 3rd & New Sts., South Bethlehem, Pa.

Here is a view of Caffrey's Hotel on the corner of Third and New Streets. Terrence C. Caffrey owned the hotel, which included a restaurant and barroom. He lived a block away at West Fourth Street with his wife, Annie, and their three children. Caffrey was a real estate investor and purchased the old Continental Hotel at Second and New Streets to renovate it into a boarding house.

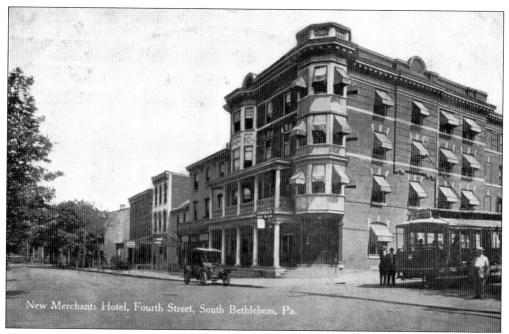

New Merchants Hotel, Fourth Street, South Bethlehem, Pa.

The New Merchants Hotel was located at 2 East Fourth Street in South Bethlehem. It was a busy location, which necessitated the "Danger Run Slow" sign for trolley car drivers. The hotel closed in 1976 and was demolished. The Regal Furniture Building was constructed on the site.

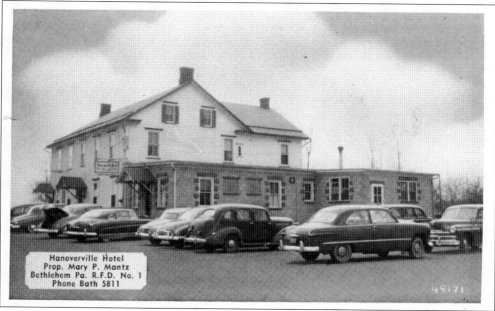

Hanoverville Hotel
Prop. Mary P. Mantz
Bethlehem Pa. R.F.D. No. 1
Phone Bath 5811

The Hanoverville Hotel, a landmark in Hanover Township, was built in 1825 as a typical Colonial-style farmhouse. In 1837, the house was converted into a hotel, general store, and post office. In the 1930s, it became known as the Road House. It was a restaurant, bar, and hunting lodge. Through the 1940s and 1950s, it was a popular family restaurant. During the 1960s and 1970s, popular rock-and-roll musicians played in the renovated club. Canned Heat and Tiny Tim drew in large crowds. Today, the building continues to house a popular restaurant.

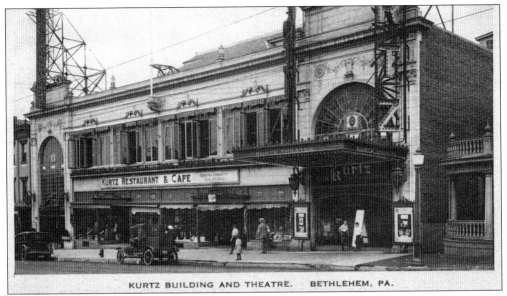

KURTZ BUILDING AND THEATRE. BETHLEHEM, PA.

The Kurtz Theater opened on September 1, 1921, with a seven-piece orchestra and several acts from Shubert Advanced Vaudeville Acts. The building of the Kurtz Restaurant and Cafe and Kurtz Theater was the dream of brothers Charles F. and John Kurtz. Between 1917 and 1921, they erected the Classical Revival–style building on Broad Street. The 1,200-seat theatre was one of the best-equipped stages in the Lehigh Valley. They sold their theater and restaurant to the Wilmer and Vincent Theatre Company in 1924.

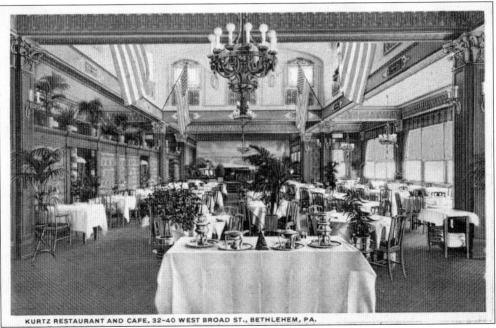

KURTZ RESTAURANT AND CAFE, 32-40 WEST BROAD ST., BETHLEHEM, PA.

The Kurtz Restaurant occupied the entire second floor of the Kurtz brothers' building. The main dining hall could serve 550 guests. A number of private dining rooms were created by removable partitions. The floor on the east side of the dining room was raised 18 inches to accommodate the theatre on the floor below and, at the same time, provide a stage for a speaker or orchestra.

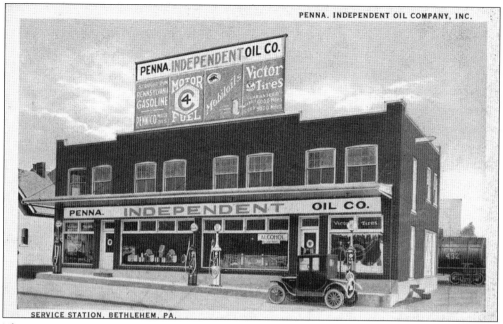

The Pennsylvania Independent Oil Company was located at 121 West Union Boulevard. A tanker truck is filling the pumps from the back of the station. Before filling stations began appearing in Pennsylvania in the early 1900s, car owners could only find gas at hardware stores. This station also sold Victor tires and Mobil oil.

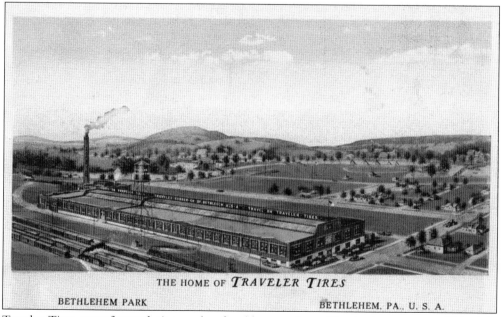

Traveler Tires manufactured tires and soft-rubber products. The business was established in Philadelphia in 1916. This building was erected in 1919 at the corner of Traveler Avenue and Auburn Street, near Route 412 on the border of Bethlehem and Hellertown. The large building is still in use today by Dreamstone Granite and Marble Company.

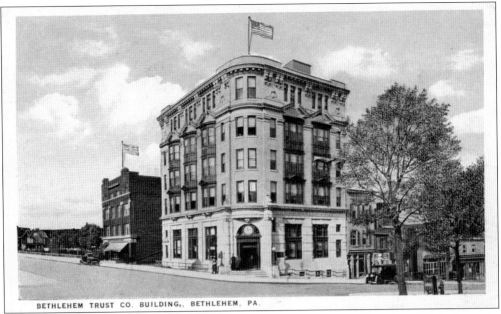

BETHLEHEM TRUST CO. BUILDING,, BETHLEHEM, PA.

The Bethlehem Trust Building was located on the northwest corner of Broad and Main Streets in West Bethlehem. The bank was chartered in 1906 and consolidated with the First National Bank and the Lehigh Valley Bank in 1932. The new bank became known as First National Bank and Trust Company. A suit against Bethlehem Steel, claiming the company was behind the merger to liquidate the assets of Bethlehem Trust Company and Lehigh Valley Bank, resulted a few years later. The suit was dismissed. The Bethlehem Housing Authority moved into the building in 1939.

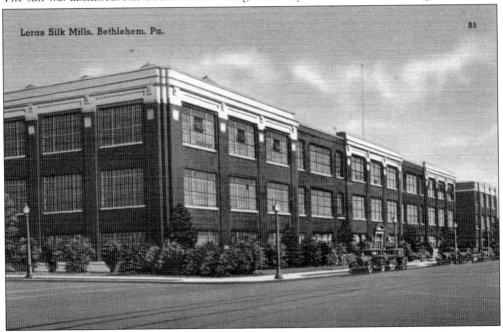

Loras Silk Mills, Bethlehem, Pa.

Here is a view of the Russell K. Laros Silk Mills at 601–675 East Broad Street. The company was organized in 1921 and employed 1,200 people to manufacture silk yarn. Each day, the company produced enough yarn to make 20,000 dozen pairs of stockings.

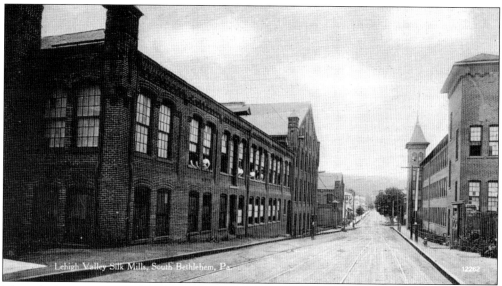

Lehigh Valley Silk Mills, South Bethlehem, Pa. 12262

The Lehigh Valley Silk Mills, the first silk mill built in the Lehigh Valley, was built in Fountain Hill in 1886. Architect A.W. Leh designed the Lipps & Sutton Mill, the first building in the group of mills. By 1918, the complex also included the Warren Mill, Lloyd Mills, and Williamsburg Mills. Bethlehem entrepreneurs A. Wilbur, Robert P. Linderman, and J. Davis Brodhead negotiated with Sutton and Lipse of New York to build a silk mill in Fountain Hill. The men had wanted to increase the job opportunities for women and children. The Lehigh Valley Silk Mill closed in 1937 because of bankruptcy. Today, the buildings, located on Seneca and Clewell Streets, are used for private residences and government offices.

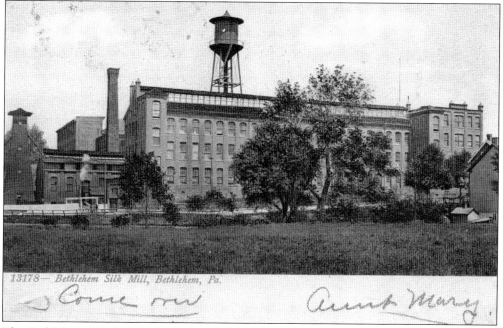

13178— Bethlehem Silk Mill, Bethlehem, Pa.

The Bethlehem Silk Mill was built in 1886, at 238 West Goepp Street. It expanded into seven buildings, making it the largest silk mill in Pennsylvania. It closed in 1952. There have been several plans to convert the building into apartments. A fire in 2006 caused $8 million in damage.

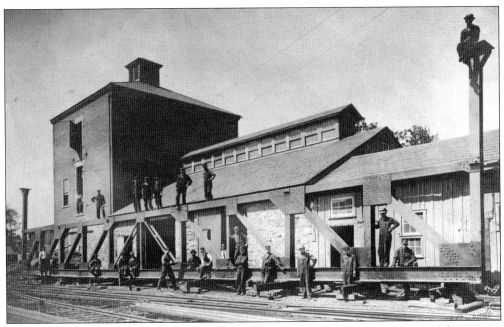

The Vanderstruken-Ewing Construction Company was located next to the Bethlehem Paint Company on Mauch Chunk Road. It must have been a slow day when the photographer came by. The whole crew appears to be posing. The railroad tracks belonged to the Lehigh & New England Railroad.

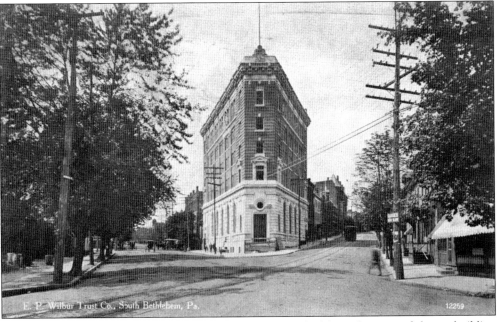

E. P. Wilbur Trust Co., South Bethlehem, Pa. 12269

Architect A. W. Leh designed the E. P. Wilbur Trust Company building. The state-of-the-art building was erected in 1910 on the triangular lot at the intersection of Broadway and Fourth Streets. Bethlehem Steel constructed the fireproof vault for the bank. The six-story building had a roof garden and a flagpole. The staff changed flags on the pole to indicate the weather. The structure remains as one of Bethlehem's most well-known buildings.

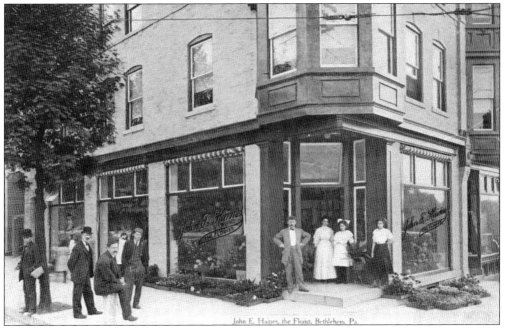

Here is a view of the John E. Haines Florist Shop. Haines was a nationally known florist, whose specialty was a variety of carnations. His advertisements stated that he sold "the best variegated carnation ever offered." His large store was located at 219–223 Laurel Street, at the intersection of Main.

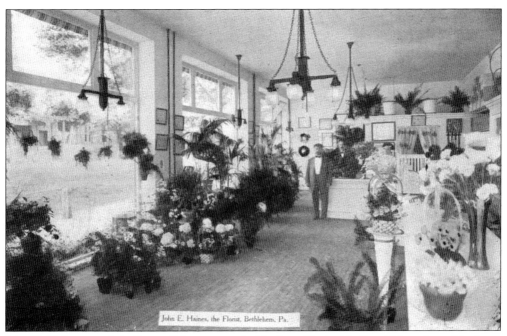

John E. Haines stands in front of the counter in his shop filled with flourishing plants. The large windows emit abundant light to see his enticing flowers and greenery. Even on a cold winter day it must have felt like summer in Haines's shop.

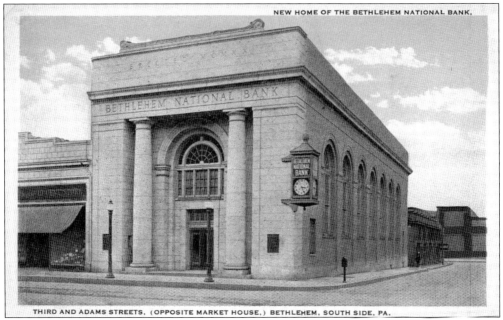

THIRD AND ADAMS STREETS, (OPPOSITE MARKET HOUSE,) BETHLEHEM, SOUTH SIDE, PA.

The Bethlehem National Bank was built across from the Market House on Third Street. It was originally incorporated as South Bethlehem National Bank in 1889. The building was erected in 1920 by Robert Pfeifle Contracting, nine years before Pfeifle became mayor of Bethlehem. This Neoclassic-style building is still in use today as a banking institution.

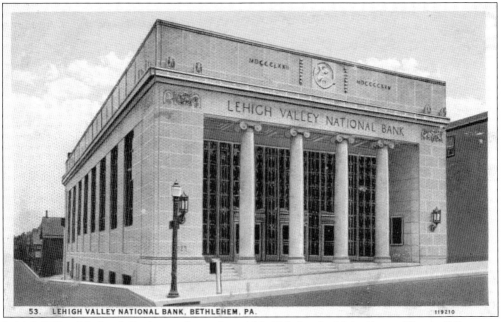

53. LEHIGH VALLEY NATIONAL BANK, BETHLEHEM, PA. 119210

Lehigh Valley National Bank was located at 103–105 South Main Street. The building was completed in 1889, allowing the bank to move from its former location at 62 South Main Street. The bank was chartered in 1872 by a group of Bethlehem entrepreneurs. It was the first banking institution not to be associated with the established Moravian businessmen. Residents could pay their Bethlehem Borough taxes at the bank.

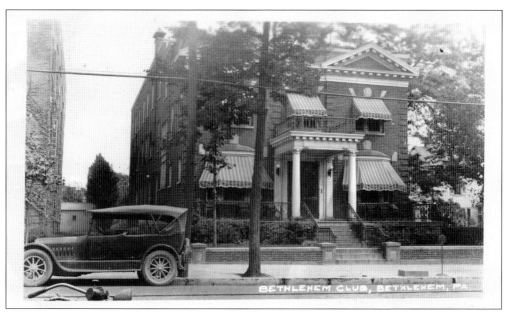

The Bethlehem Club building still stands on the 500 block of New Street. The 18,000-square-foot building was designed by architect A.W. Leh and built in 1909. Bethlehem Steel Company used the facility to house its new hires of young engineers. The building contained a dining room and bar on the first floor, multiple banquet rooms and a bar on the second floor, and 12 dormitory rooms on the third floor. The club is said to be haunted by the irate wife of a Bethlehem Steel executive. The wife discovered her husband in one of the dormitory rooms with another woman. In chasing her husband, she accidently fell down the stairs, which led to her death. The social club closed in 2007. The building currently serves as offices for Glemser Technologies.

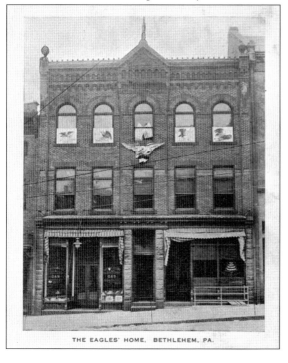

THE EAGLES' HOME, BETHLEHEM, PA.

The Fraternal Order of Eagles (FOE) was located at 453 Main Street. The Allentown-Bethlehem Gas Company occupied the first floor. Theater owners in Seattle founded the FOE in 1898. Their motto is "People Helping People," and the organization still has a branch in Bethlehem today.

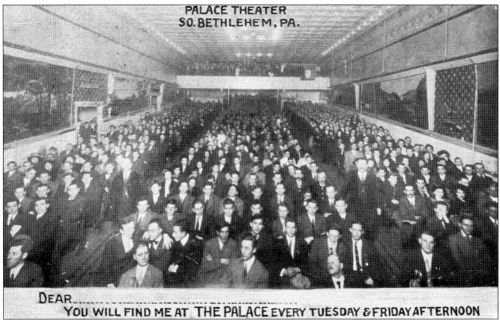

The Palace Theater, located at 206 East Third Street, sat 1,000 people. The theater was built in the 1920s and competed for business with four other movie houses in town. It offered several promotions, such as the businessman's special, shown on the card. In 1996, the New Bethany Ministries gutted the insides of the theater, leaving just the facade, to build a home for mentally challenged adults.

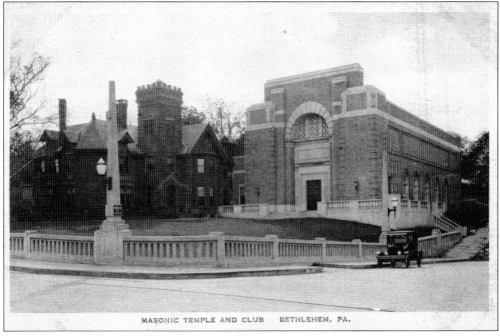

Elisha Packer Wilbur built his mansion in 1864 in Fountain Hill, across from the Anthracite Building. He was able to keep a close eye on his business concerns, the E.P. Trust Company and the Lehigh Valley Railroad. The Masonic Temple on the right was built in 1926 after the Masonic Lodge purchased the mansion and surrounding lot the year before.

Ten

RECREATION AND PARKS

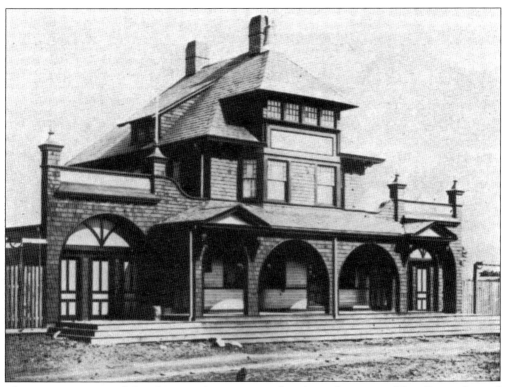

The main entrance of the fairgrounds was a grand and stately stone edifice. It was located directly across from Liberty High School. The fairgrounds included a picnic grove, flashy midway, horse races, livestock, home and agricultural products, and a 1,500-seat grandstand. There was a Machinery Hall to showcase state-of-the-art industrial technology. The Bethlehem Fair offered foot races, high-wire acts, trapeze artists, and boxing contests to entertain Bethlehem residents throughout the year. A trolley line traveled along unpaved Linden Street to the fairgrounds.

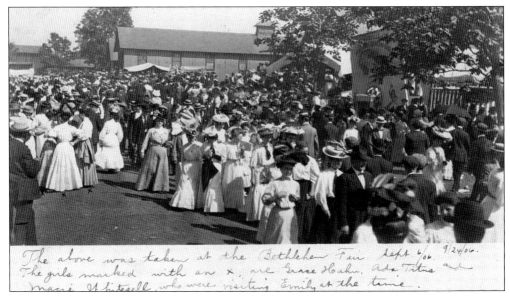

The above was taken at the Bethlehem Fair Sept 6/06. 9/24/06.
The girls marked with an x, are Grace Hahn, Ada Titus and
Marie Whitesell, who were visiting Emily at the time.

The opening day of the horse races at the Bethlehem Fair always brought a crowd of several thousand people, predominately men. Foot races also drew large crowds. Races between local volunteer fire companies would draw thousands of spectators. Because of high maintenance costs, in October 1909, the association put the fairgrounds on the real estate market. The grounds were sold to developers Edgar and William Speck, Elwood Barber, William Applegate, and T.D. Fritch for $50,000.

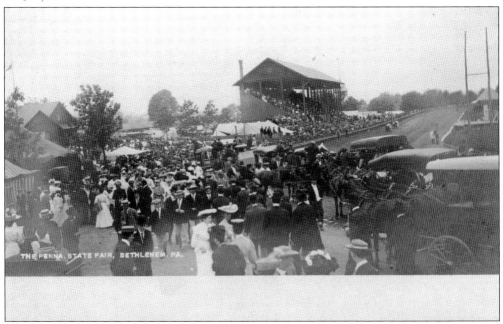

The Pennsylvania State Fair, which traveled throughout Pennsylvania, opened at the new Bethlehem Fairgrounds on September 21–26, 1891. The Bethlehem Fair and Driving Park Association was founded by a group of local businessmen. The association purchased 35 acres in the area of Liberty High School, known as North Bethlehem. They began work on the grounds in April 1891 and by September were ready to host the fair.

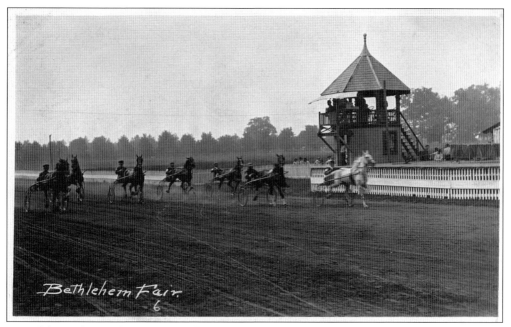

Part of the tradition of Pennsylvania fairs was harness racing. The Bethlehem track was considered one of the best and fastest half-mile tracks in the East, especially for sulky racing (two-wheeled, one-horse carriages for one person). The grounds contained more than 200 horse stalls and sheds for cattle and poultry.

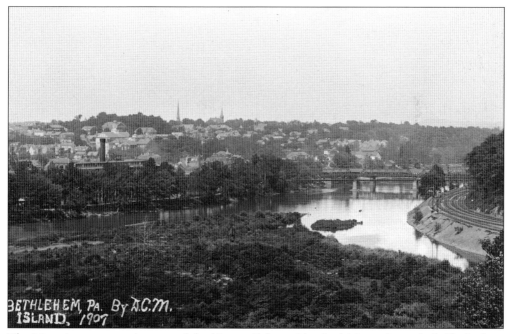

The Moravian congregation owned the 13-acre Calypso Island, which was located a half mile from the Hill-to-Hill Bridge. In 1903, they sold the island to the Lehigh Valley Railroad for $20,000. The railroad company then filled in the channel between the island and the bank on the south side of the Lehigh River to lay track there. The island is actually a part of the bank we see today.

111

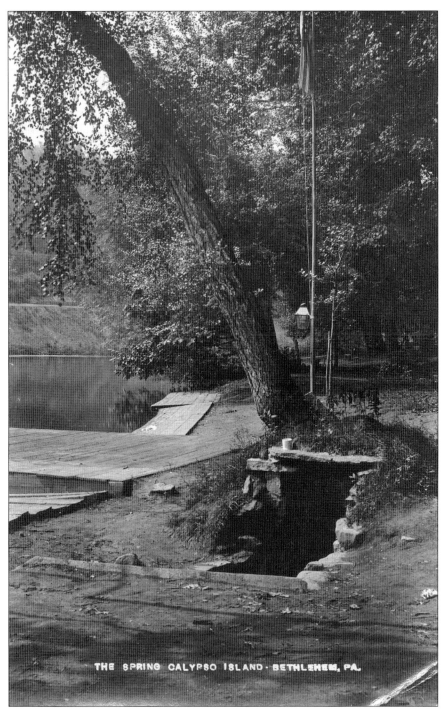

THE SPRING CALYPSO ISLAND · BETHLEHEM, PA.

Bethlehem families packed picnics and boarded one of the ferry boats to transport them to the beautiful Calypso Island. On the island, they found winding paths through lush trees and shrubs. There was a carousel for the children and an octagonal gazebo to rest in the shade. There were several wooden tables to set up a picnic. State representative George Henry Goundie named the island for a sea nymph in Greek mythology during a Fourth of July celebration in 1869.

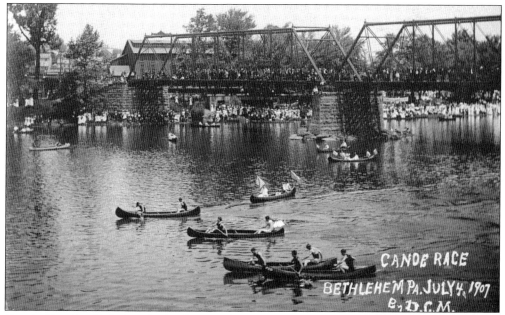

On the Fourth of July, hundreds of people lined up along the banks to watch the canoe regatta. Lehigh University students raced each other, interclass. Lehigh students organized several boating clubs beginning in the 1870s. The Lehigh River was not ideal for serious racing, however, because of its the wide variations in depth and flow. Canoeing and boating on the Lehigh continued through the 1920s.

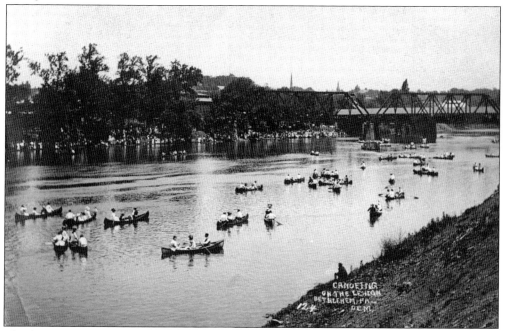

The demise of Calypso Island in 1903 did not curtail recreation on the Lehigh River. Cabins for the canoes and rowboats were built along the southern bank of the Lehigh. It was a convenient place to keep canoes, especially for those who belonged to one of the canoe clubs. The railroad truss bridge is in the background.

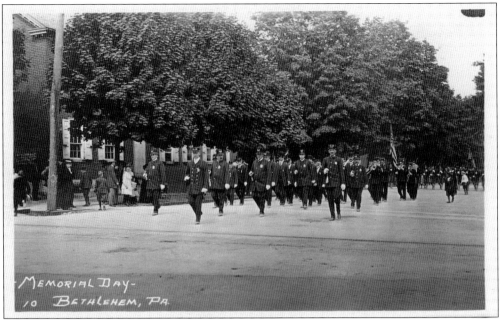

The first national celebration of Memorial Day took place May 30, 1868, at Arlington National Cemetery, where both Confederate and Union soldiers were buried. The day was originally called Decoration Day, as people decorated the graves of soldiers with flowers and wreaths. At the turn of the twentieth century, the name of the day was changed to Memorial Day. The day was always celebrated with a parade. This is a view of Bethlehem police marching in a parade in 1910.

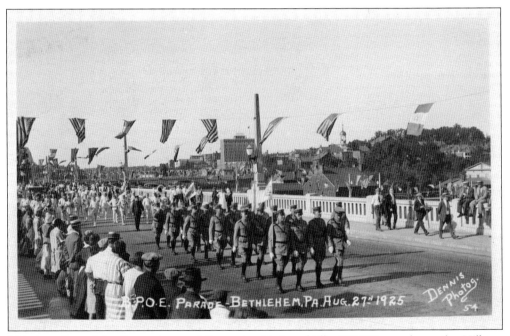

This is a view of the Benevolent and Protective Order of Elks (BPOE) parade on the Hill-to-Hill Bridge on August 27, 1925. Visiting Elks members from Scranton are looking sharp in their summer dress uniforms and high leather boots.

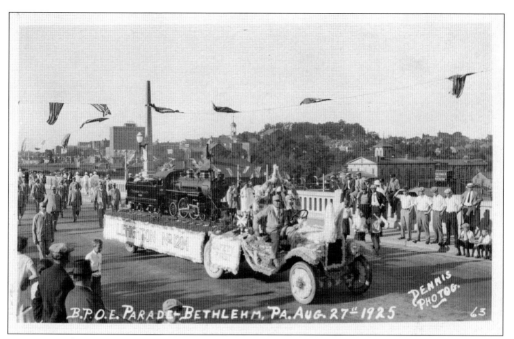

Here is another view of the same parade on the Hill-to-Hill Bridge. The center of the action is a float from the Lehigh Valley Railroad. The gentlemen driving the float and walking beside it are dressed as train engineers. The Lehigh Valley Railroad ceased operations in 1961.

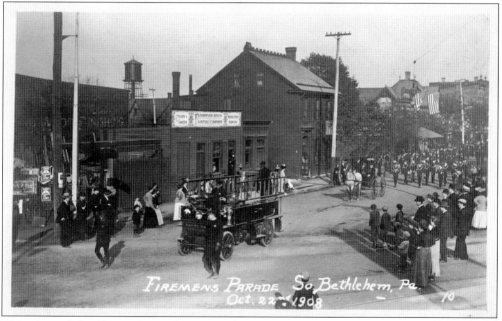

This view of the Firemen's Parade on October 22, 1908, in South Bethlehem included a fire truck from Wayne, Pennsylvania, a horse and carriage, and a marching band. The parade passed the Colver & Ganzer Pompeian Brick Painting Company, house and sign painters. All the fire departments in the city participated in the yearly fall parade to demonstrate how well their engines and carriages were cared for.

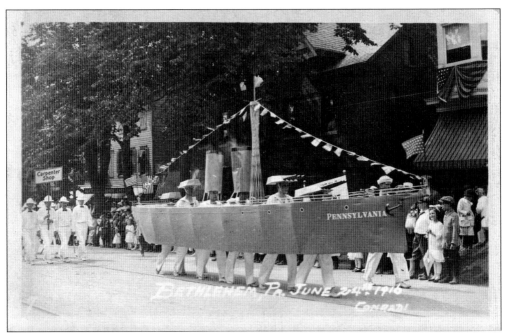

This is a view of a parade float of the battleship USS *Pennsylvania*. Inside the float were six people. Workers from the Bethlehem Steel carpenter shop follow. The parade, on June 24, 1916, celebrates the official opening of Bethlehem Steel's new athletic field. The homes and businesses along the parade route are decorated in red, white, and blue.

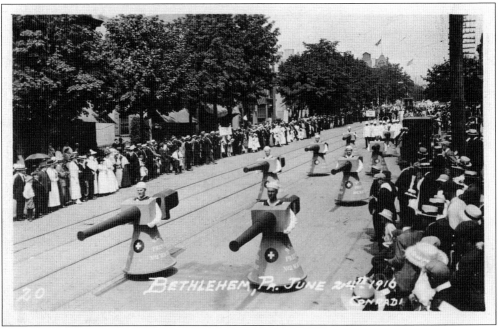

This is another view of the parade to celebrate the new athletic field on June 24, 1916. The men are wearing naval gun costumes and are followed by workers from the boiler shop. Each float and costume represented a product of Bethlehem Steel.

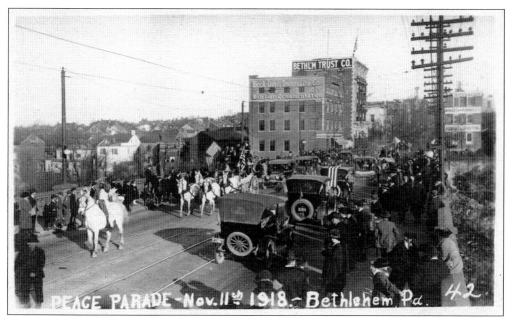

This is a view of an Armistice Day peace parade on the Broad Street Bridge on November 11, 1918. Seen is a man on horseback, a carriage pulled by four horses, and several accompanying automobiles. The buildings of Beck-Davis Decorating Company and Bethlehem Trust Company are prominent in the background. On this day, hostilities ceased in World War I. Everyone in Bethlehem lined the sidewalks to cheer for the end of the war and this impromptu parade.

In 1937, the Works Progress Administration (WPA) built the stone walls, bridges, and paths to create the Monocacy Park we know today. It was built from a swampy area on the north side of Bethlehem. In 1907, the Borough of Bethlehem purchased the property, including Illick's Mill.

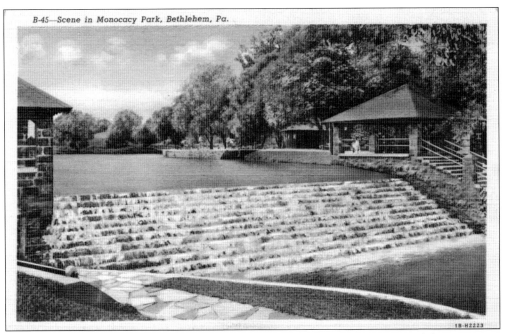

B-45—Scene in Monocacy Park, Bethlehem, Pa.

This view is of the dam in Monocacy Park. In 1937, the WPA dredged and widened the Monocacy Creek. They erected the granite dam and a raceway. The park was dedicated in August 1937, with a band playing on a bandstand temporarily placed in the middle of the creek.

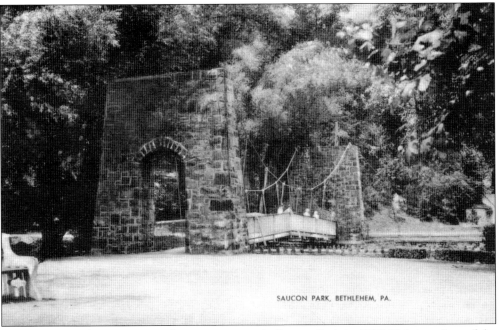

SAUCON PARK, BETHLEHEM, PA.

The WPA built the same types of stone structures in Saucon Park in 1937. This is a view of the pedestrian bridge. Two fish hatcheries were built but were never used. In the 1920s, residents of South Bethlehem enjoyed walking to the beautiful rose gardens in Saucon Park. Peter D. Shelbo designed the gardens. The park borders South Bethlehem and Hellertown.

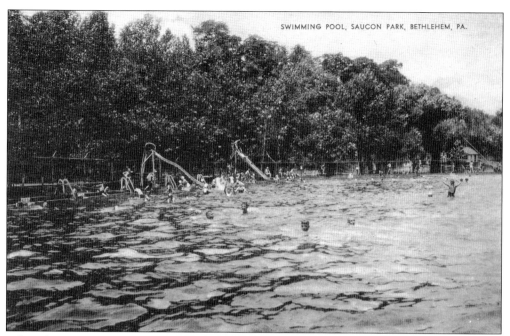

When this swimming pool opened in 1925 at the foot of East Fourth Street in Saucon Park, adults were charged 25¢ and children 15¢ for a day of cool, wet fun. On a Sunday during the first summer of operation, the pool attracted 10,000 people, 15 percent of Bethlehem's population at the time. The pool was replaced in 1988.

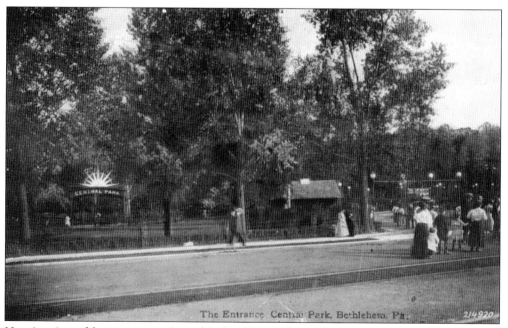

Here is a view of the entrance to Central Park, which was located on Hanover Avenue in Rittersville, between Bethlehem and Allentown. The Allentown Bethlehem Rapid Transit Company opened the park on July 2, 1893. The transit company had purchased 40 acres from the Thomas Ritter farm to erect a trolley barn and amusement park.

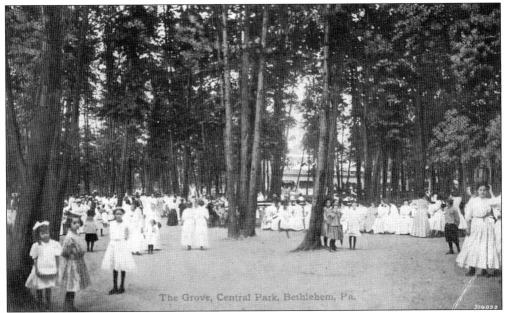

The Grove, Central Park, Bethlehem, Pa.

When the Allentown Bethlehem Transit Company created Central Park, including a menagerie, merry-go-round, and picnic grounds, their trolley line could bring customers from Allentown and Bethlehem. The fare was 5¢ from Allentown to Rittersville, and 5¢ from Rittersville to Bethlehem. The electric trolleys followed the Allentown-Bethlehem Turnpike (now Hanover Avenue), which was a toll road with three tollgates.

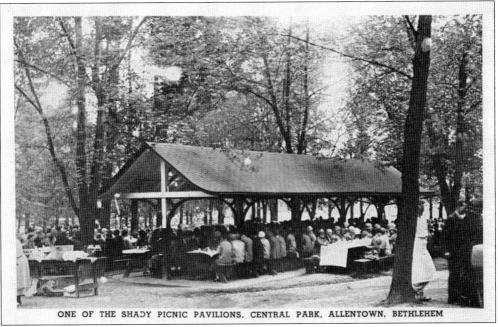

ONE OF THE SHADY PICNIC PAVILIONS, CENTRAL PARK, ALLENTOWN, BETHLEHEM

When the Lehigh Valley Transit Company bought Central Park in 1905, the park went through a tremendous expansion. The company invested $75,000 on several new rides, such as the Derby Racer, Circle Swing, and Shoot the Chute. Attendance for the 1911 season numbered more than 650,000. Trolley company police enforced a liquor ban.

120

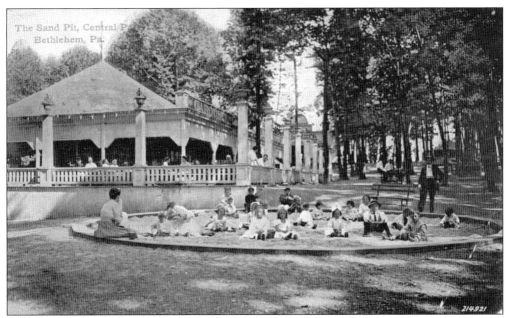

Here is a view of the sand pit and carousel at Central Park. The idea of a sand pit originated in Germany in the mid-1800s. When this sand pit was installed in the early 1900s, it was a great attraction for the younger set. The children pictured look clean and well dressed in their finest clothes. The photograph was taken before they had a chance to engage in much playing. On Christmas Day 1951, a disgruntled park watchman set a fire that destroyed the carousel.

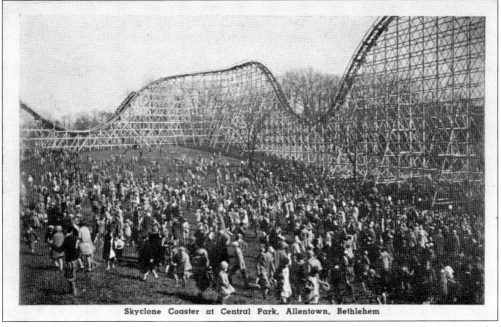

Skyclone Coaster at Central Park, Allentown, Bethlehem

The Skyclone Coaster surrounds a great crowd at Central Park in this photograph. In 1927, the Cyclone roller coaster, called "the longest, most thrilling amusement ride in the country," was added. In 1935, a fire destroyed the Cyclone coaster, and it was replaced with the Skyclone, which was in operation until the park's closure in 1957.

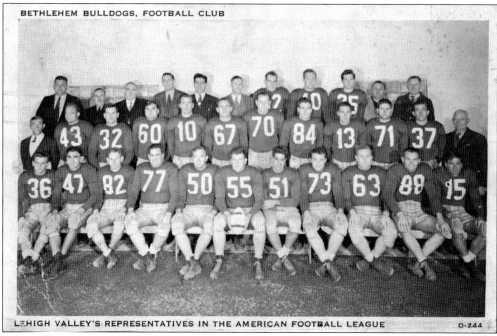

BETHLEHEM BULLDOGS, FOOTBALL CLUB

LEHIGH VALLEY'S REPRESENTATIVES IN THE AMERICAN FOOTBALL LEAGUE O-244

Bob Sell created the Bethlehem Bulldogs team in 1946. They were a part of the American Football League and a farm team of the Philadelphia Eagles. The year of this postcard, 1947, the Bulldogs had eight wins and only one loss. Their successful year placed them in the league championship playoff game against the Paterson Panthers. Bethlehem won against Paterson with a score of 23-7. The Bulldogs quit the league in 1950 because of financial difficulties. It was a talented team with many of its players moving up to the National Football League: Ray Dini, Leon Price, Bob Sostar, Clyde Biggers, Bill Hoydt, Tom McGeoy, Bill Wehr, and Harlan Dedrick.

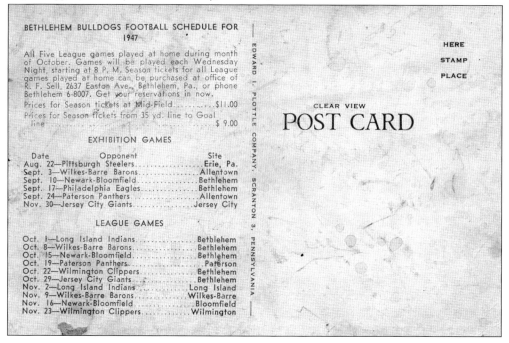

BETHLEHEM BULLDOGS FOOTBALL SCHEDULE FOR 1947

All Five League games played at home during month of October. Games will be played each Wednesday Night, starting at 8 P. M. Season tickets for all League games played at home can be purchased at office of R. F. Sell, 2637 Easton Ave., Bethlehem, Pa., or phone Bethlehem 6-8007. Get your reservations in now.

Prices for Season tickets at Mid-Field$11.00
Prices for Season tickets from 35 yd. line to Goal line$ 9.00

EXHIBITION GAMES

Date	Opponent	Site
Aug. 22—Pittsburgh Steelers		Erie, Pa.
Sept. 3—Wilkes-Barre Barons		Allentown
Sept. 10—Newark-Bloomfield		Bethlehem
Sept. 17—Philadelphia Eagles		Bethlehem
Sept. 24—Paterson Panthers		Allentown
Nov. 30—Jersey City Giants		Jersey City

LEAGUE GAMES

Oct. 1—Long Island Indians		Bethlehem
Oct. 8—Wilkes-Barre Barons		Bethlehem
Oct. 15—Newark-Bloomfield		Bethlehem
Oct. 19—Paterson Panthers		Paterson
Oct. 22—Wilmington Clippers		Bethlehem
Oct. 29—Jersey City Giants		Bethlehem
Nov. 2—Long Island Indians		Long Island
Nov. 9—Wilkes-Barre Barons		Wilkes-Barre
Nov. 16—Newark-Bloomfield		Bloomfield
Nov. 23—Wilmington Clippers		Wilmington

EDWARD I. PLOTTLE COMPANY, SCRANTON 3, PENNSYLVANIA

CLEAR VIEW
POST CARD

HERE
STAMP
PLACE

In 1984, Musikfest was born, and it has been wildly successful ever since. Jeff Parks had proposed the idea as a way to bring in much-needed revenue to Bethlehem. Parks, along with the tourism committee of the Bethlehem Area Chamber of Commerce, gathered hundreds of volunteers to create a summer German festival showcasing music and cultural arts. (Courtesy of Tim Gilman.)

Musikfest 1984 offered five entertainment platzes with 118 performers and 295 performances. Scheduled to perform that week were pop singer Don McLean, famous for his hit "American Pie;" the Louis Armstrong All-Stars; the Stadtkapelle Berching Band, from West Germany; and many local performers, such as Dave Fry, John Gorka, and the Rob Stoneback Big Band. From pop music to symphonies, there was something for everyone, and all performances were free. It was a wonderful celebration of music, art, and food for the residents of the Lehigh Valley. (Courtesy of Hub Wilson.)

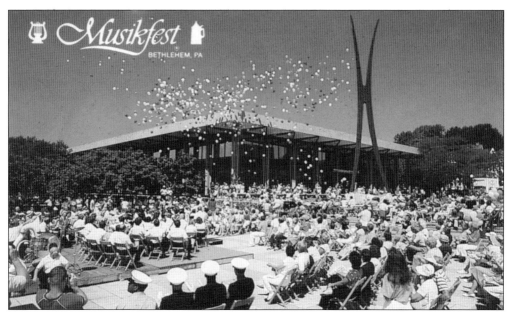

In 1985, a new platz, Americaplatz, was created at the city center area between the city hall and the Bethlehem Public Library. Main Street between Broad and Market Streets was closed for the first time. Gov. Dick Thornburgh signed a Musikfest bill, allowing the organizers to obtain a temporary liquor license. *Destinations Magazine* listed Musikfest on its roster of international events. Musikfest 1985 drew more than 400,000 attendees. (Courtesy of Angelo Caggianno.)

The Musikfest Chicken, Patricia Holetz, entertained the community every August by flapping her wings and dancing on the Festplatz dance floor to the song "The Chicken Dance." She made her first appearance at the 1984 Musikfest and retired at the end of the 2006 festival. She made her final appearance at the 2008 Musikfest to celebrate its 25th anniversary. Patricia now lives in Florida with her husband, Kalman. (Courtesy of Hub Wilson.)

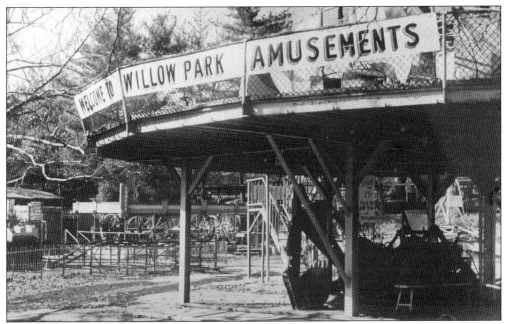

Above the entrance sign to Willow Park is the flying scooter ride. Willow Park was an old-fashioned family amusement park on 18.3 acres in Butztown in Bethlehem Township, near Nancy Run Creek. Daniel Shelbo opened the park in 1931 with two attractions and a wide-open lawn for family picnics. Daniel S. Horninger purchased the property in 1959 for $125,000 and added 11 amusement rides. The park closed in 1969. John Posh, president of Posh Construction Co., purchased the property in 1971.

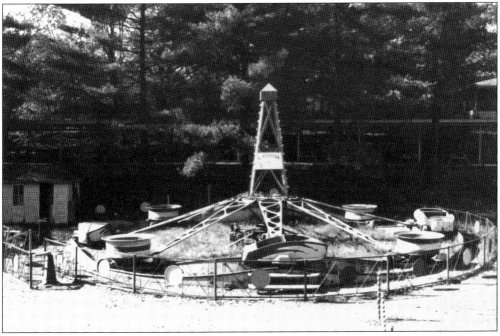

Here is the C-Cruise ride that offered thrilling experiences of speed for the younger visitors. All they needed was a 5¢ ticket to select their car. Behind the ride were the pavilions for family picnics.

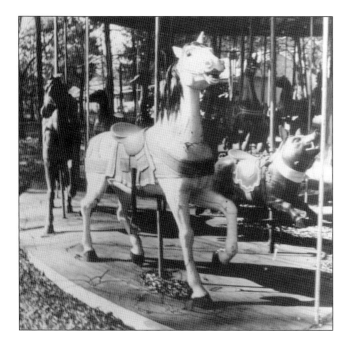

This is the merry-go-round, the standard ride of any amusement park and always a favorite. A child had his or her choice of a horse or pig to ride. The ride turned counter-clockwise. The lively postures of the wooden animals explains why merry-go-round horses and other animals are still highly collectible today.

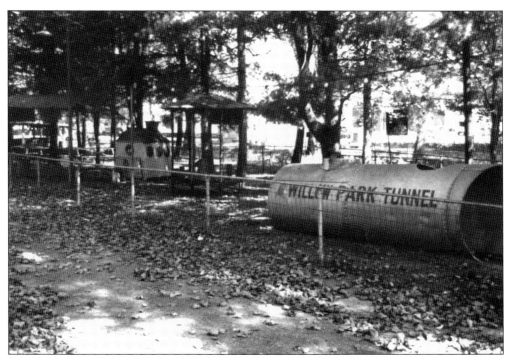

Seen here is the kiddie handcar ride. Daniel S. Horninger added this very popular self-propelled car ride. Children would peddle their car by hand through the large metal pipe known as Willow Park Tunnel.

Pictured is 16-year-old Marge Blatnik Bilheimer, a lifeguard at the Willow Park pool. She was trained by the American Red Cross and earned $1.50 an hour. It was 1964, but the management always played music of the 1940s by the pool. On a hot summer day, the pool was so packed that people were shoulder-to-shoulder in the pool. Marge worked as a lifeguard for three summers before she went away to college. Not only did she feel the owners and employees were one happy family, but her siblings were also employees of the park. Her sister Diane worked in the ladies changing room and the ticket stand. Her brother John worked in the men's changing room.

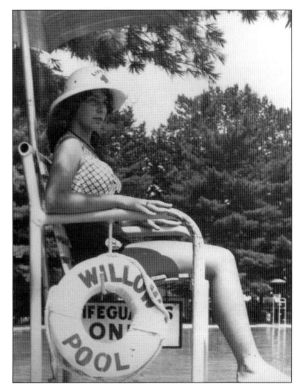

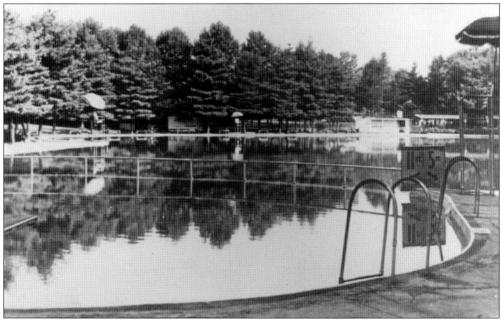

The pool, on the site of a former cow pasture, measured 34,754 square feet and held about 850,000 gallons of cold, fresh water. The Shelbo family dug the massive pool by hand. The park added chlorine to keep the water clean, but on occasion, the chemical turned some swimmers' hair a shade of green. There was a beach at the shallow end. Perhaps some readers remember the vinegar French fries and frozen candy bars.

DISCOVER THOUSANDS OF LOCAL HISTORY BOOKS
FEATURING MILLIONS OF VINTAGE IMAGES

Arcadia Publishing, the leading local history publisher in the United States, is committed to making history accessible and meaningful through publishing books that celebrate and preserve the heritage of America's people and places.

Find more books like this at
www.arcadiapublishing.com

Search for your hometown history, your old stomping grounds, and even your favorite sports team.